mandalas

mandalas

art by

Jeffrey Spahr-Summers

Cherry

Boulder, Colorado

First Edition

Copyright
Jeffrey Spahr-Summers
Cherry Publications 2014, 2019
All Rights Reserved

Books by Jeffrey Spahr-Summers

Poetry

Fear of Heights (1984)
The Cherry Poems (2006)
i believe (2009)
broke before love shack (2009)
jet streaks and power lines (2009)
fifteen minutes (2009)
20 Poems (2014)
6 Days (2014)
History, Poems Written in Chicago 1988-1993 (2014)
no exit (2014)
apple road (2014)

Photography

odaroloc (2009)
green tangerines (2014)
aftereverythingdonebeenflooded.
moon (2014)
mandalas (2014)

Also by Cherry Publications

Non-Practicing Virgin by Marissa Lehto (Poetry, 2014)

Ballad of Todd Last Year by Matt Clifford (Poetry, 2016)

"I had to abandon the idea of the superordinate position of the ego." – Carl Jung

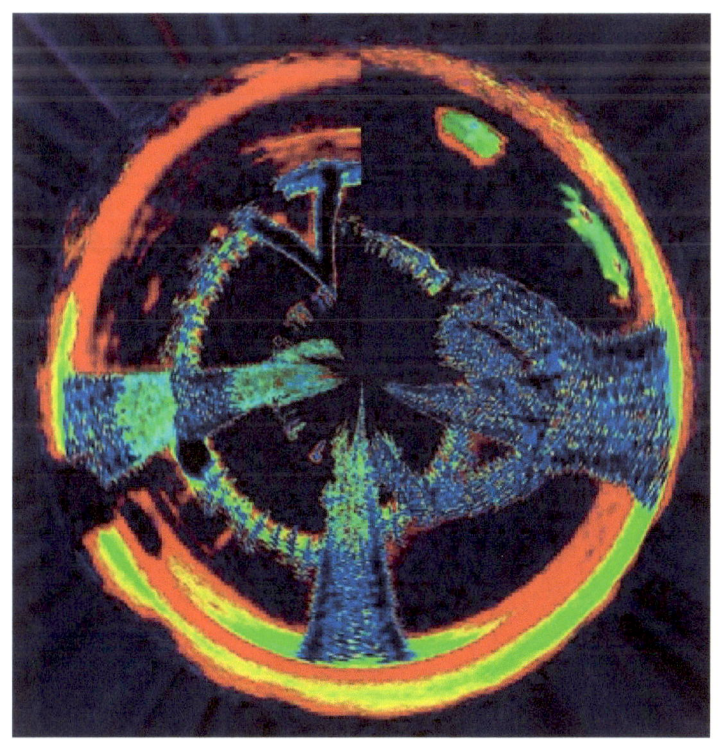

anger

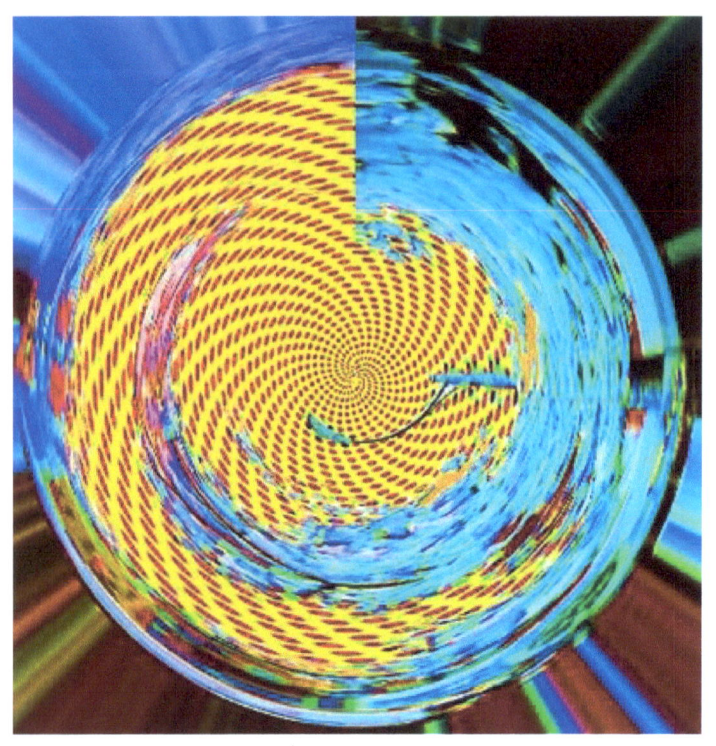

anticipation

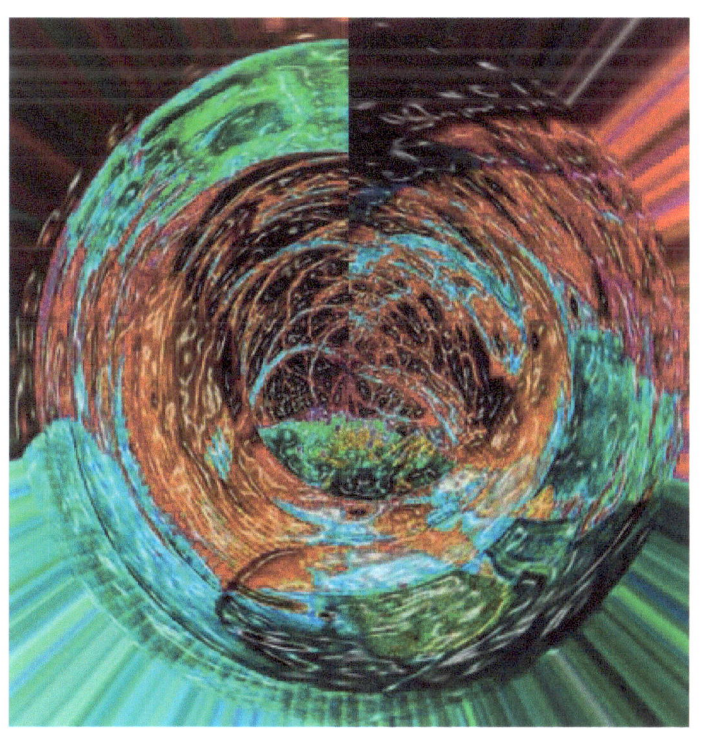

anxiety

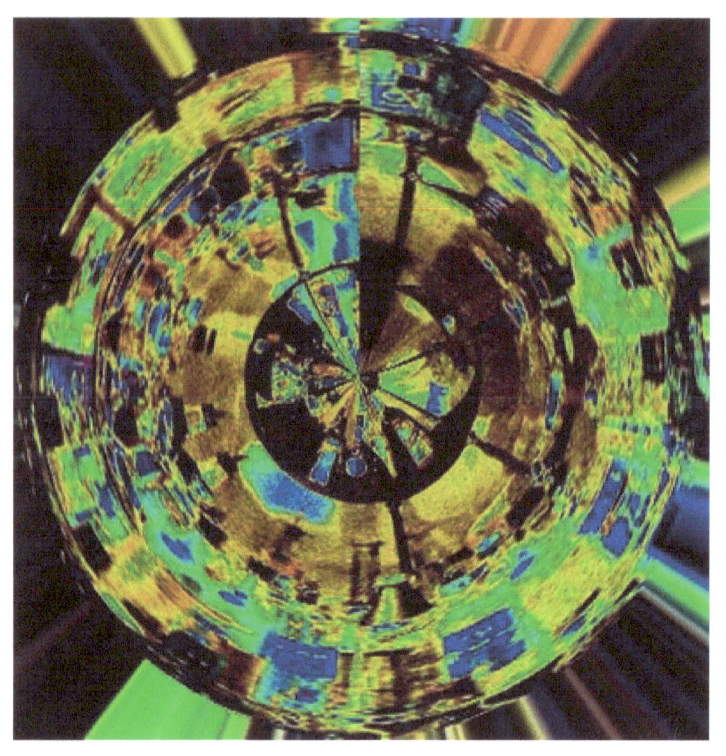

appearances

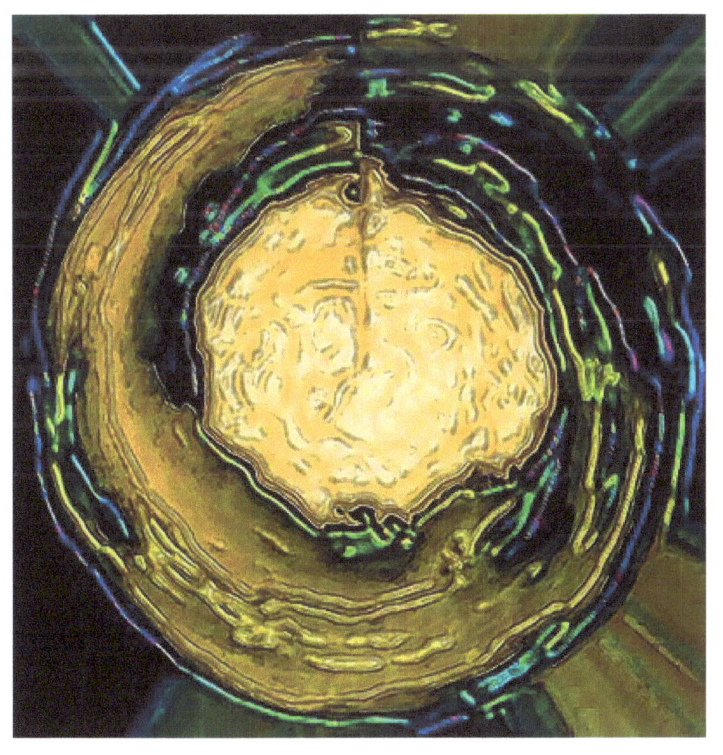

attraction

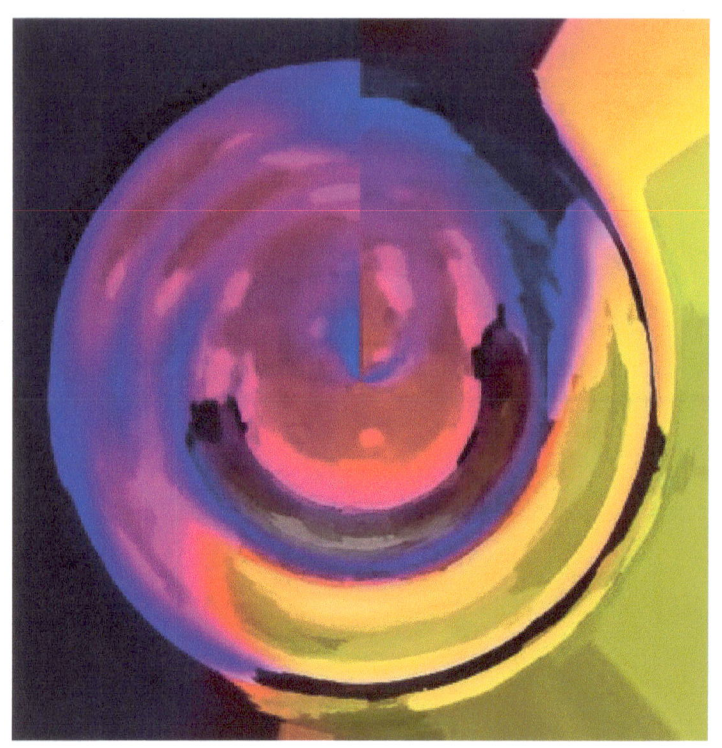

birth

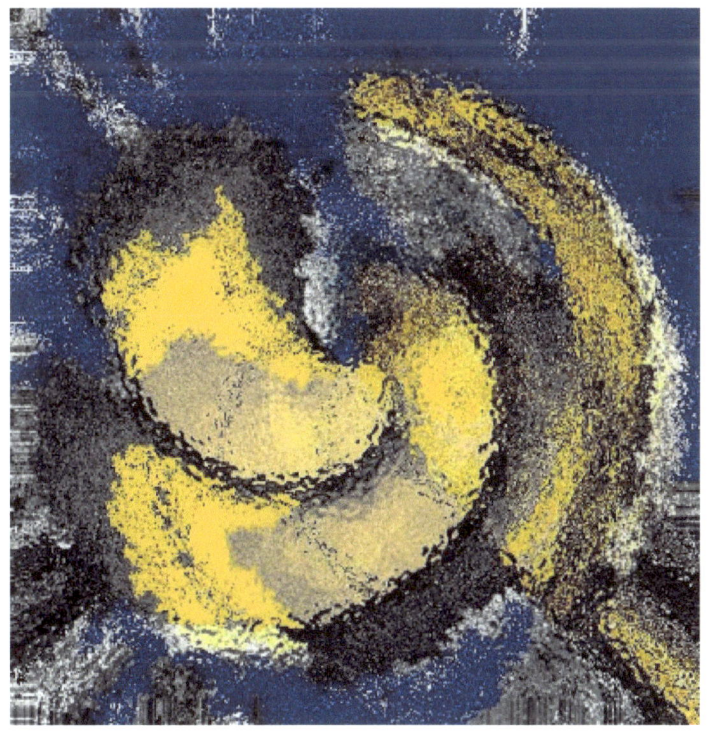

bliss

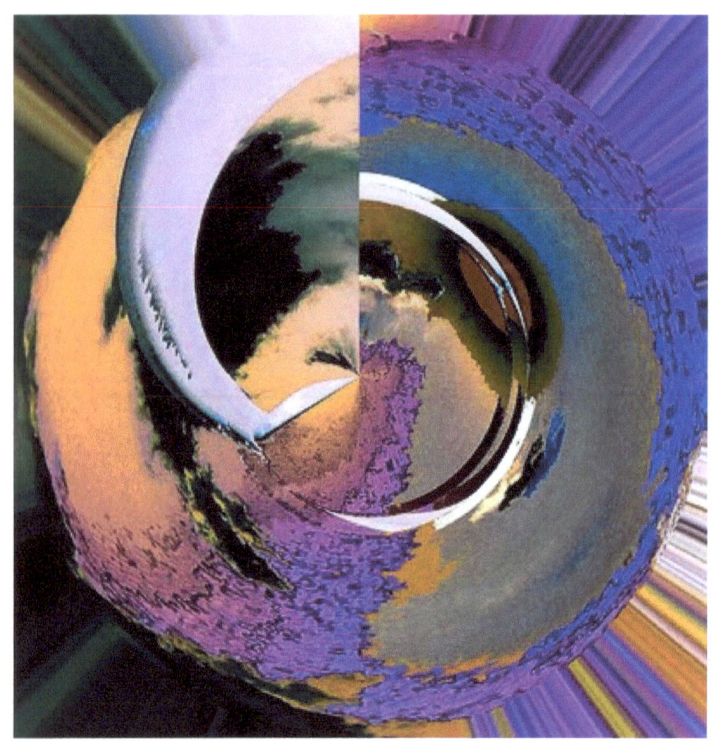

change

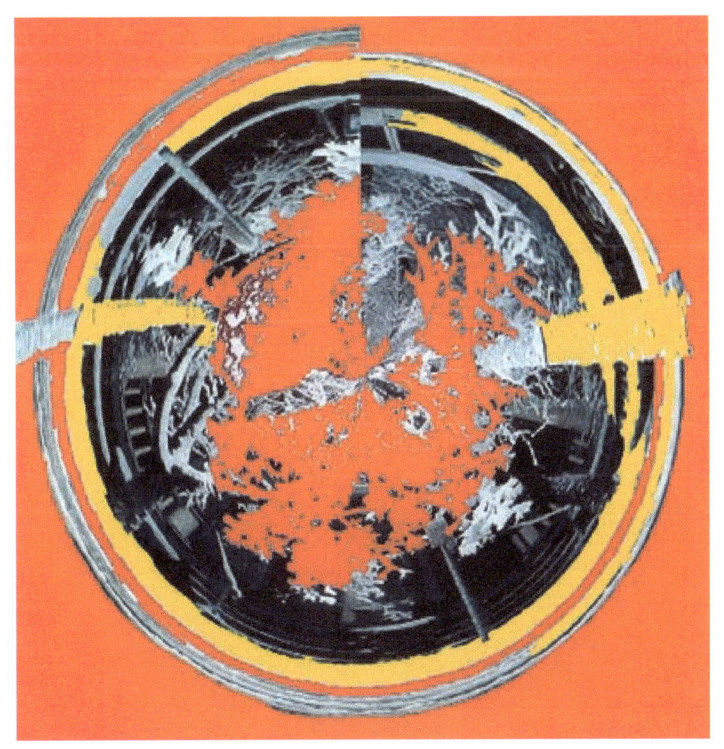

communication

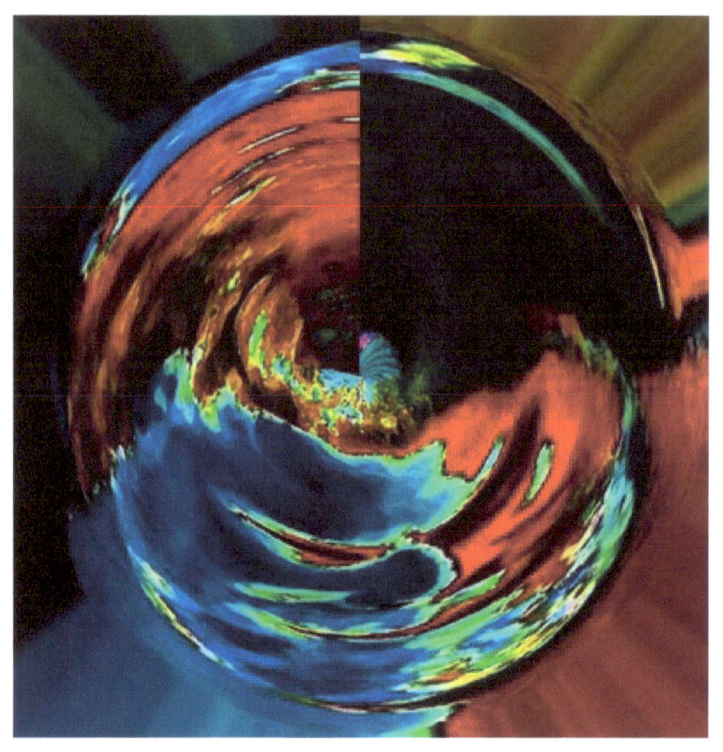

confusion

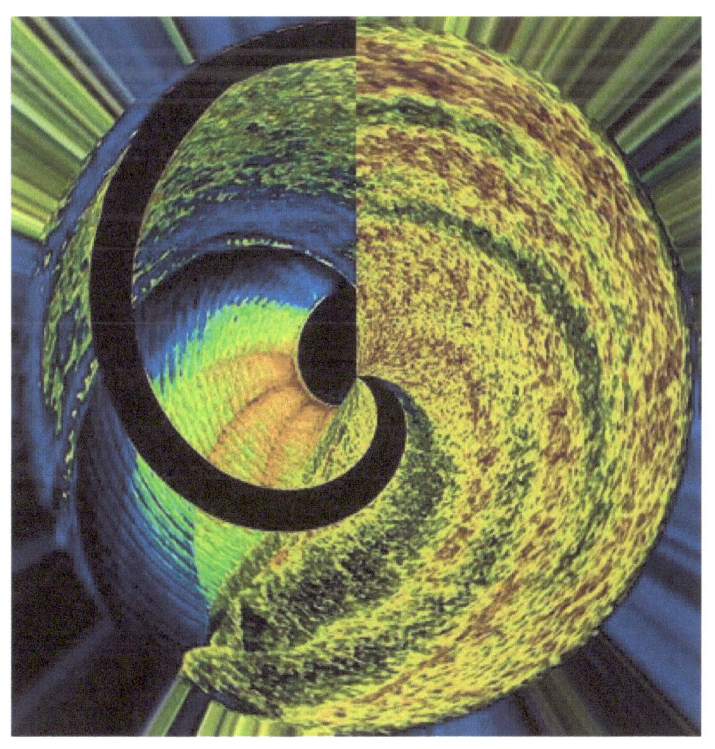

creativity

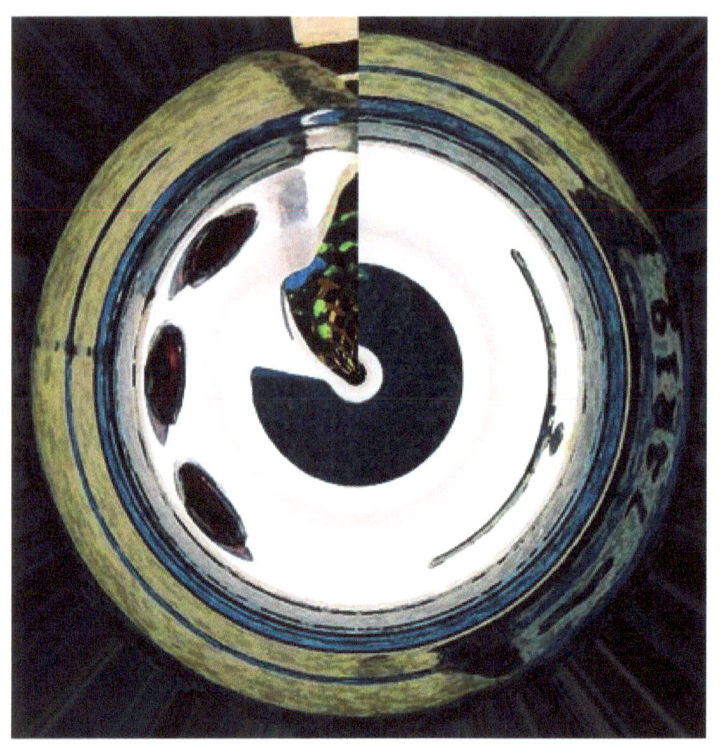

curiosity

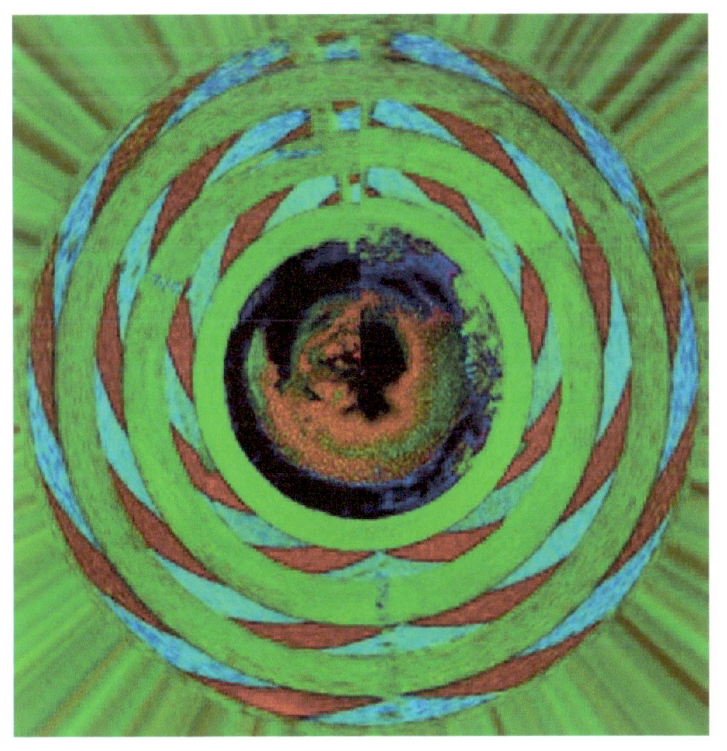

denial

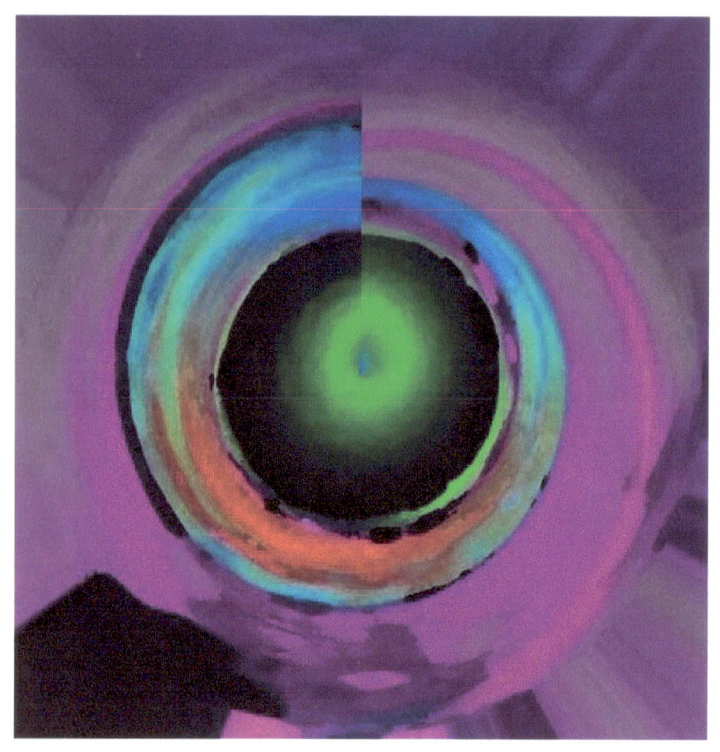

desire

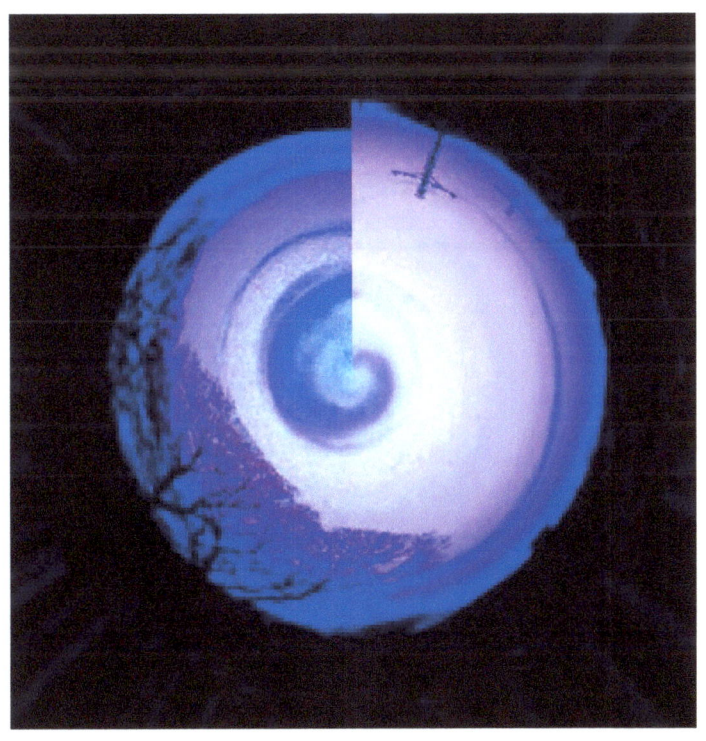

dream

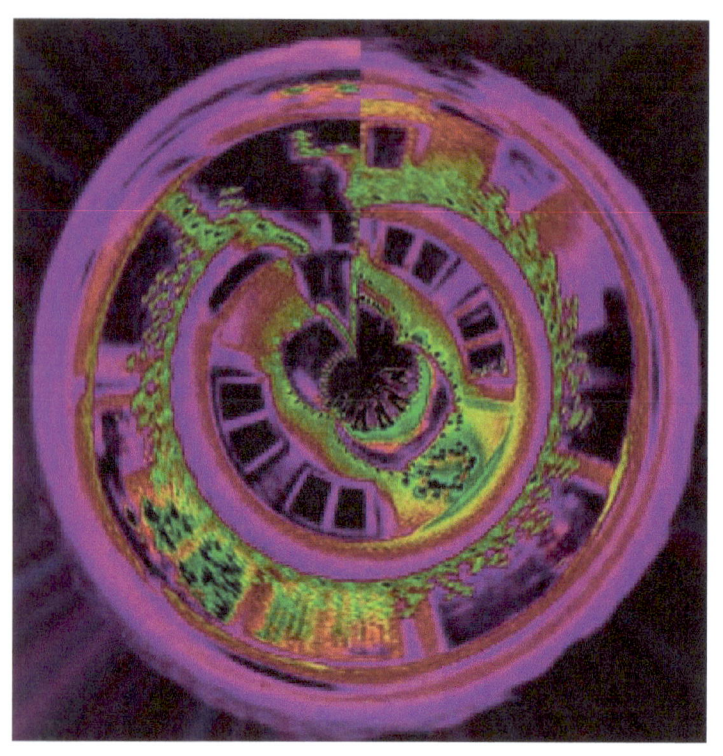

ecstasy

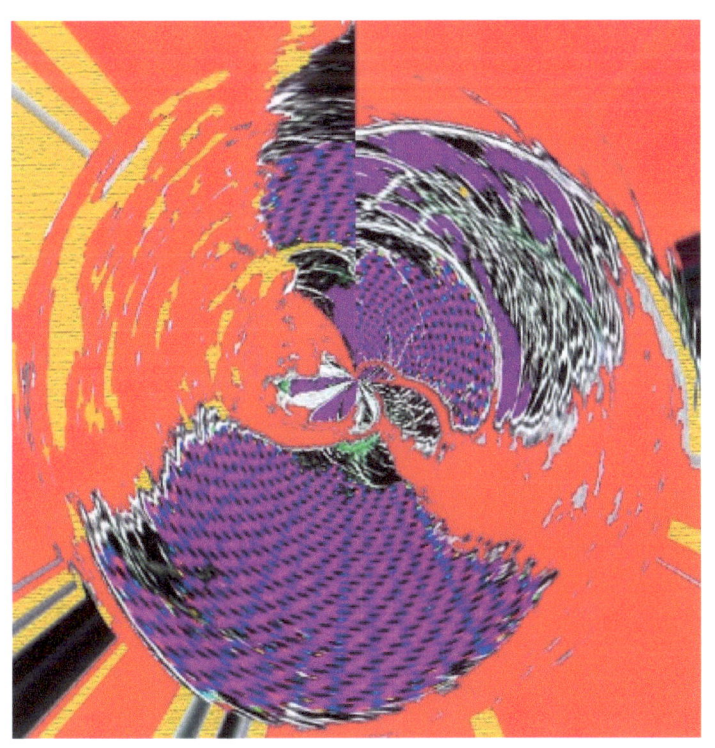

electric

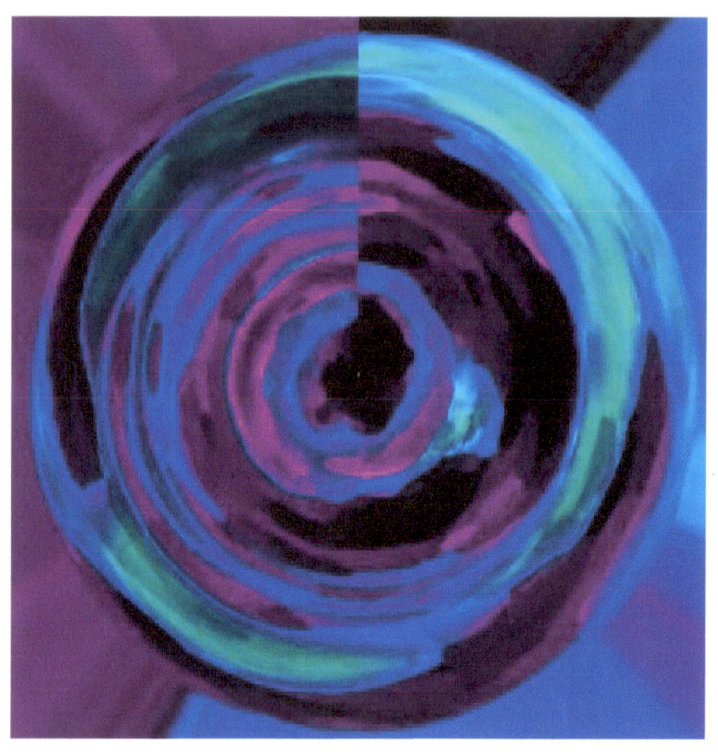

empathy

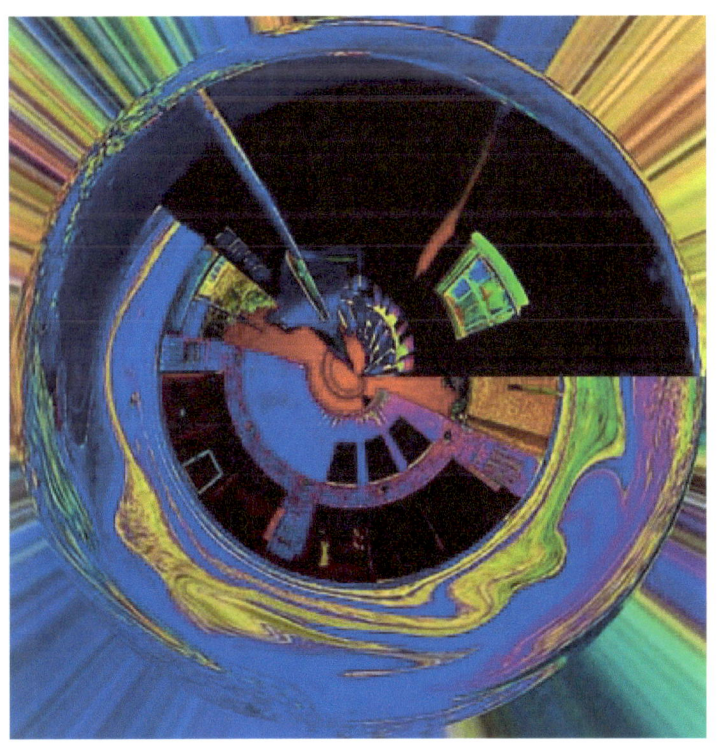

excitement

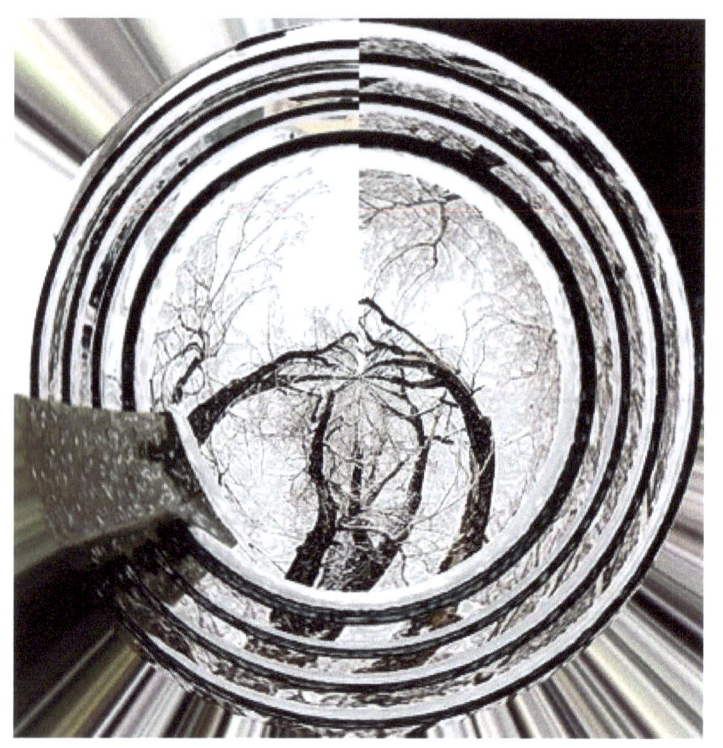

fate

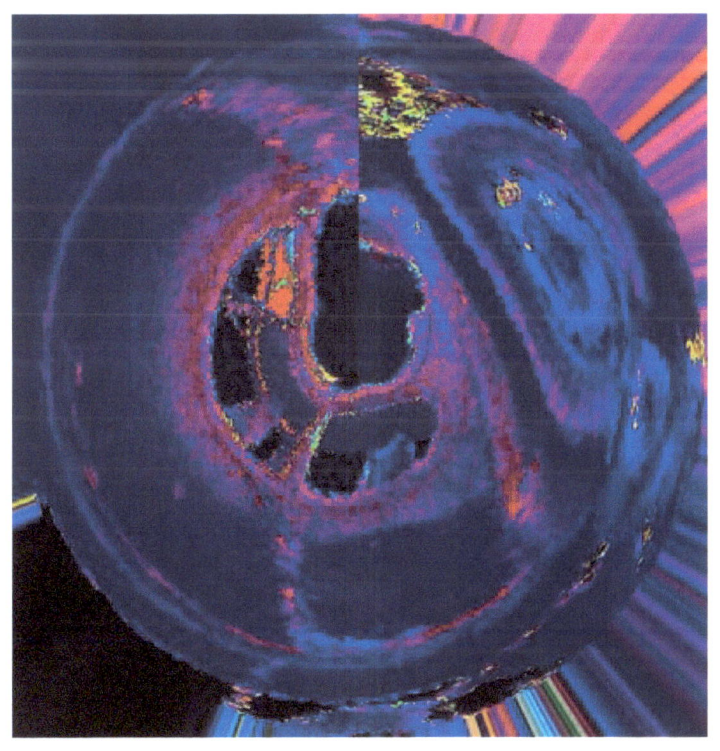

fear

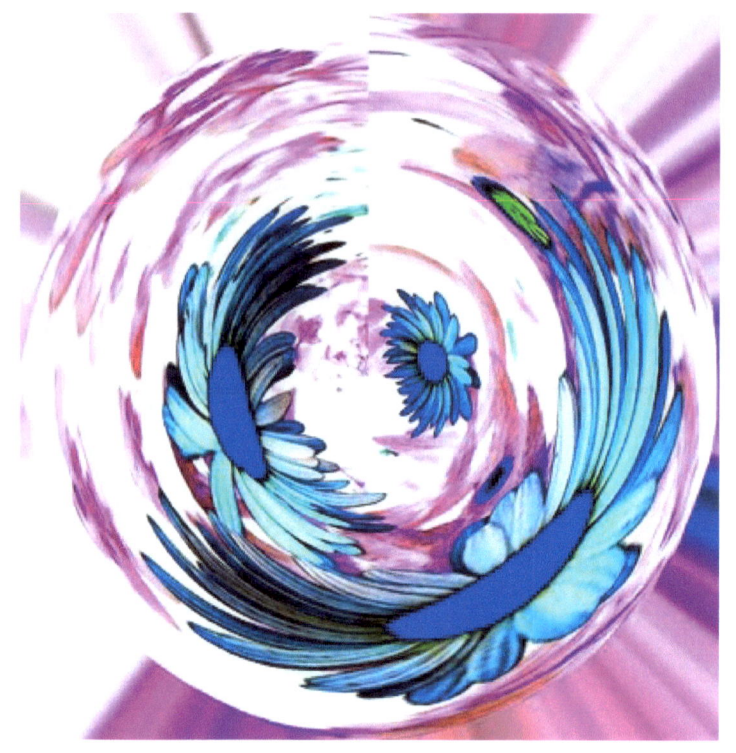

flowers in the wind mandala

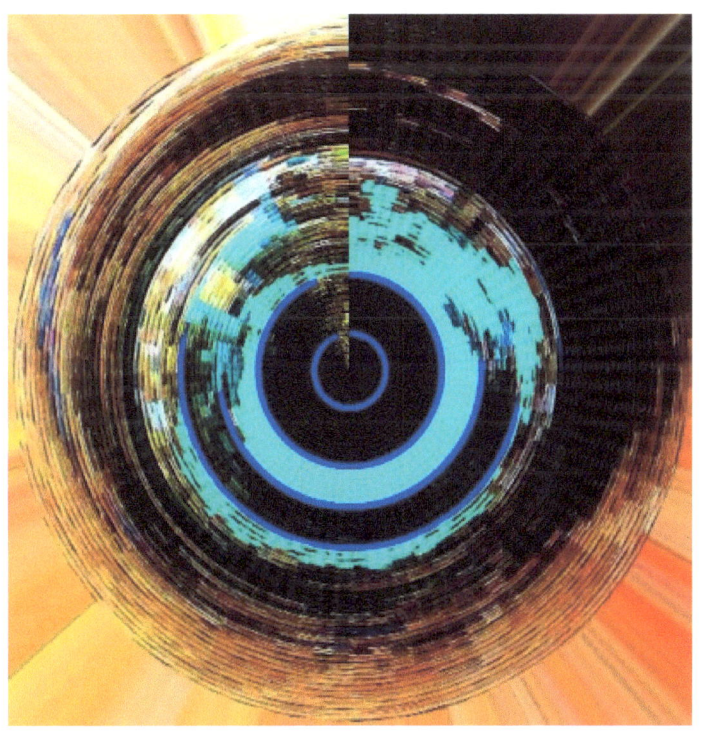

focus

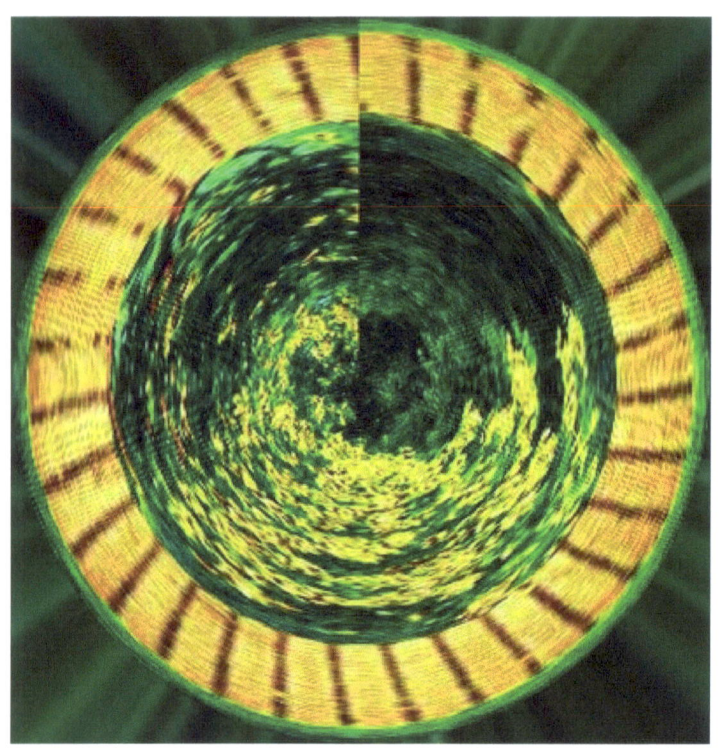

forgiveness

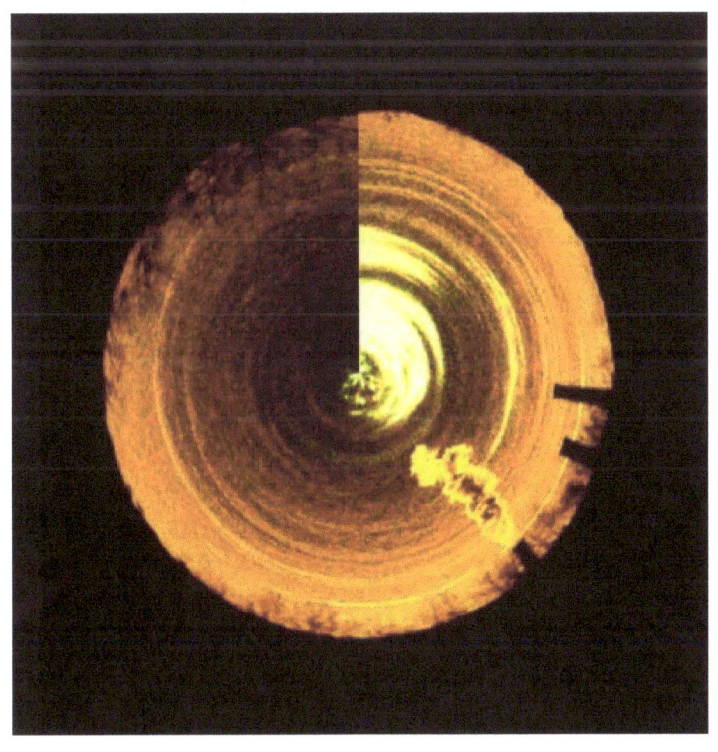

greed

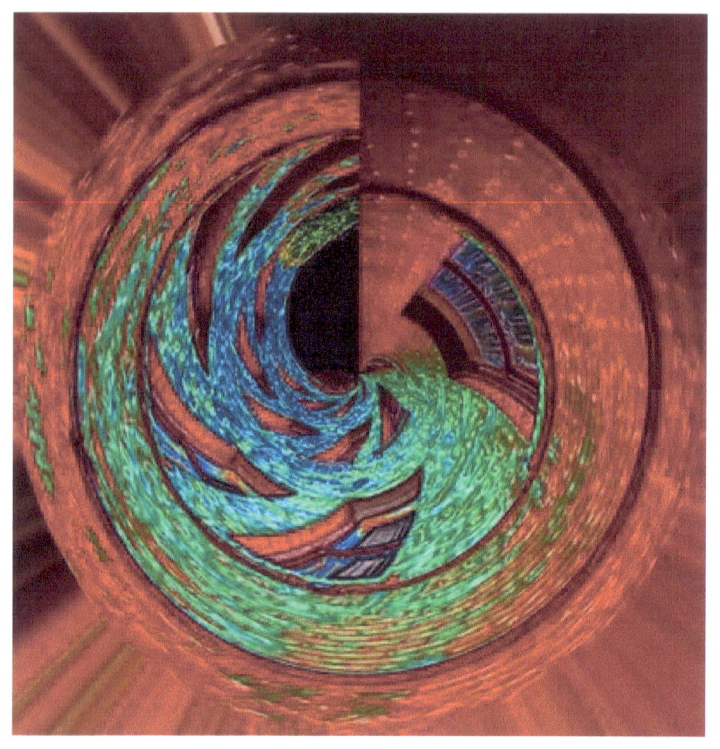

hindsight

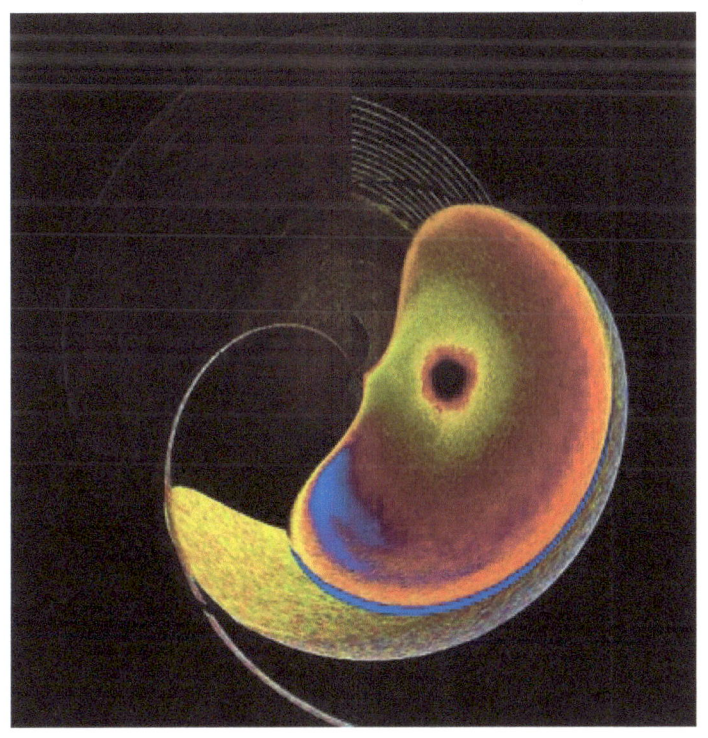

hope

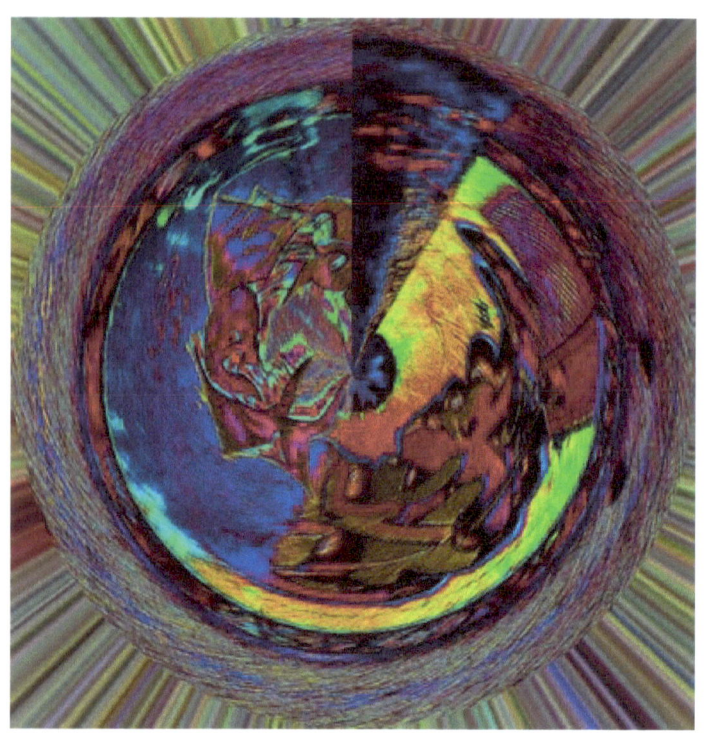

hunger

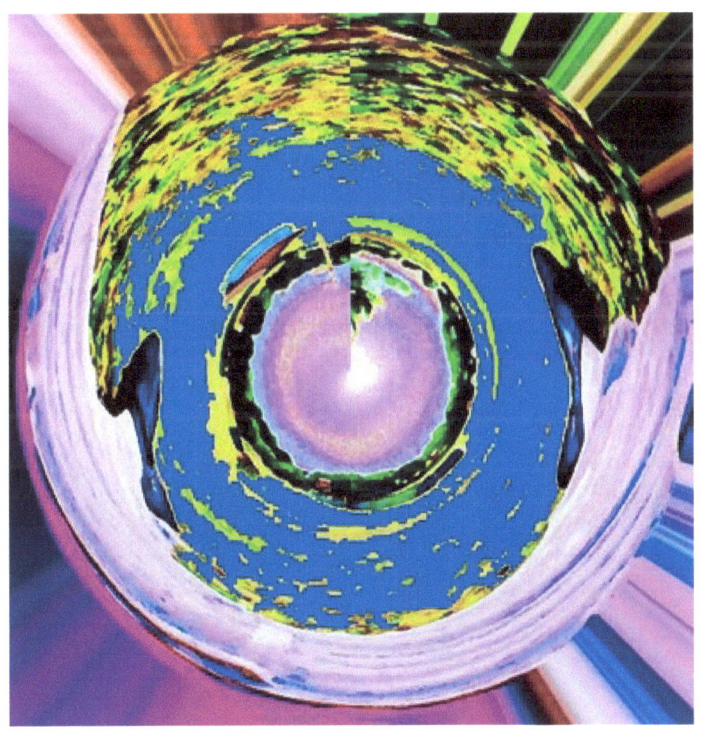

innocence

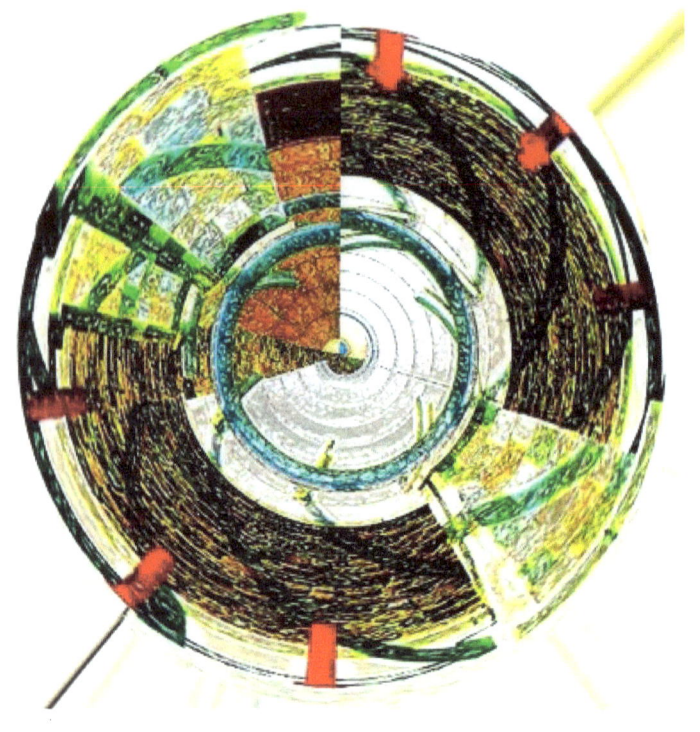

inspiration

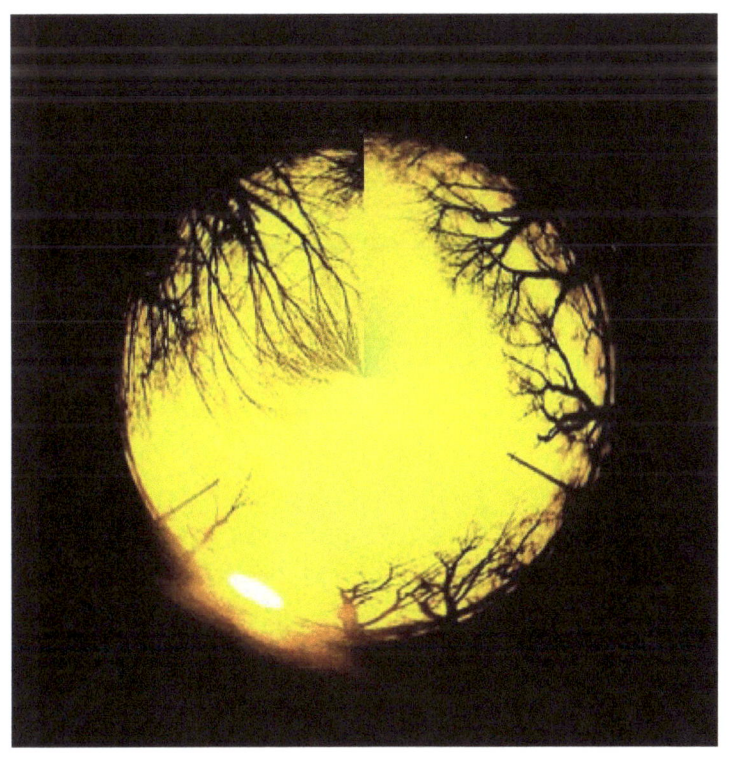

instinct

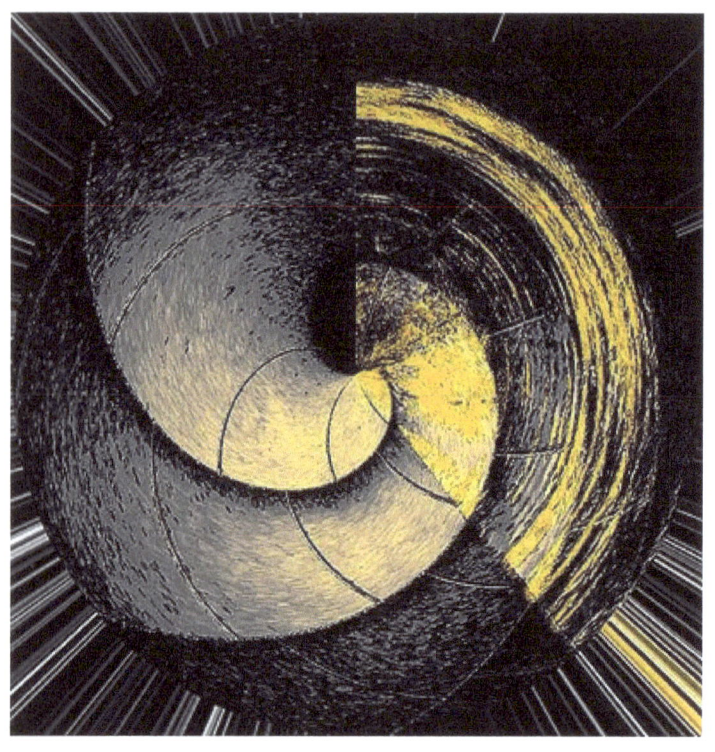

intuition

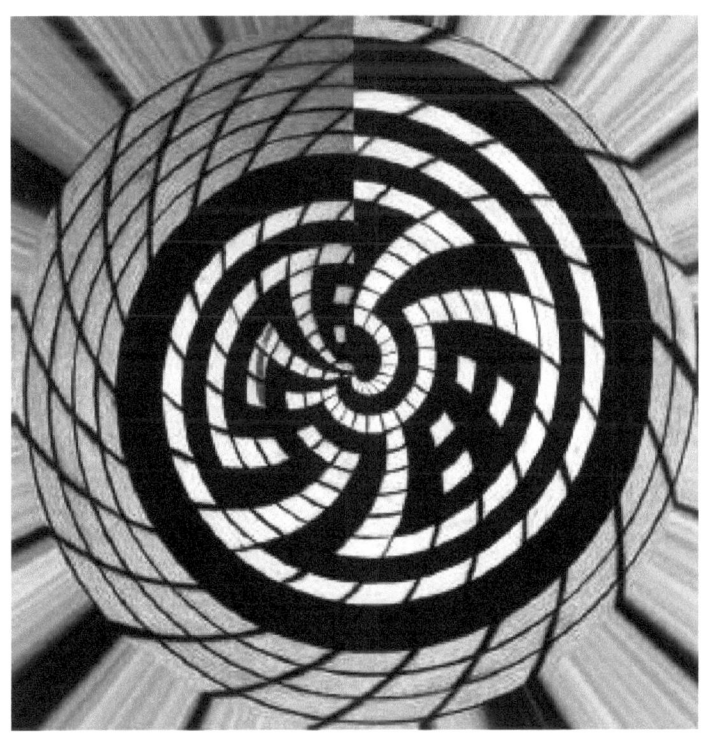

irony

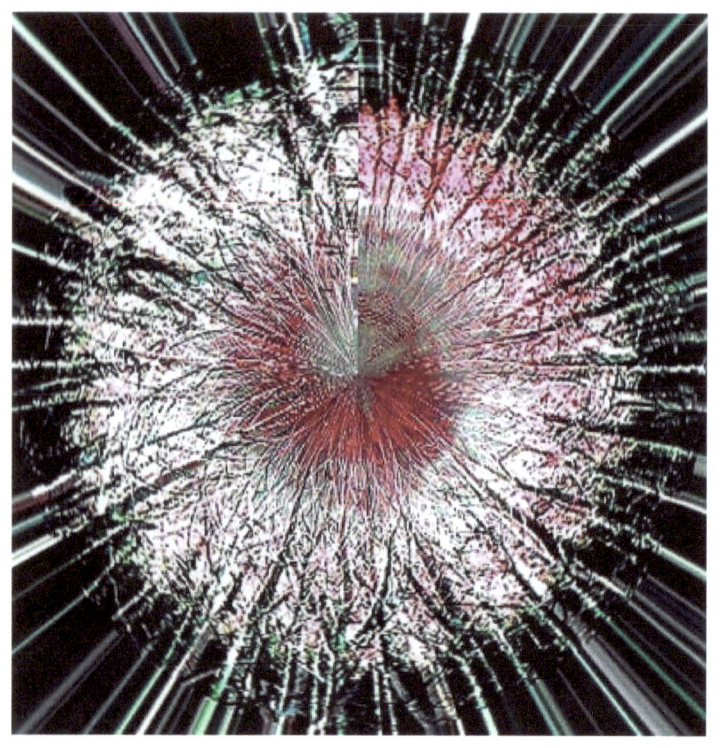

jealousy

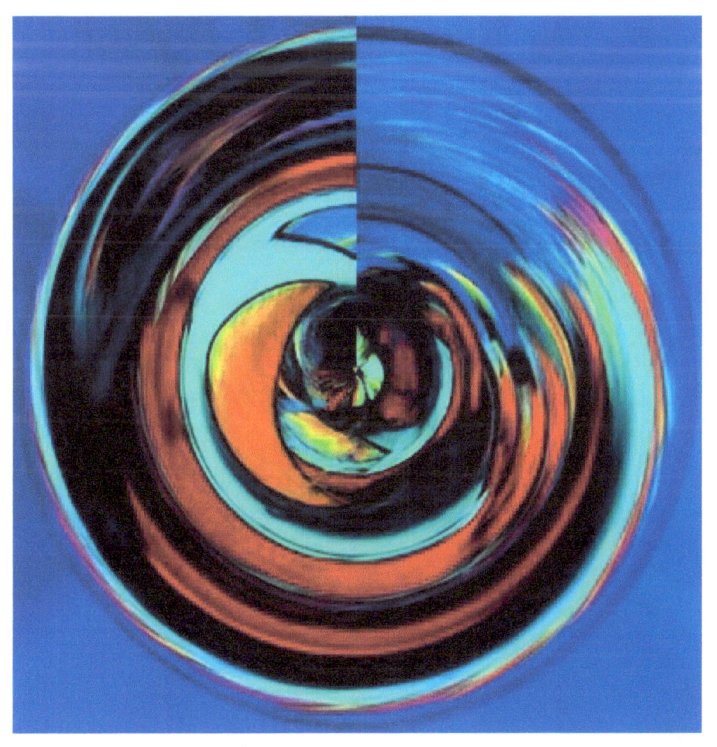

joy

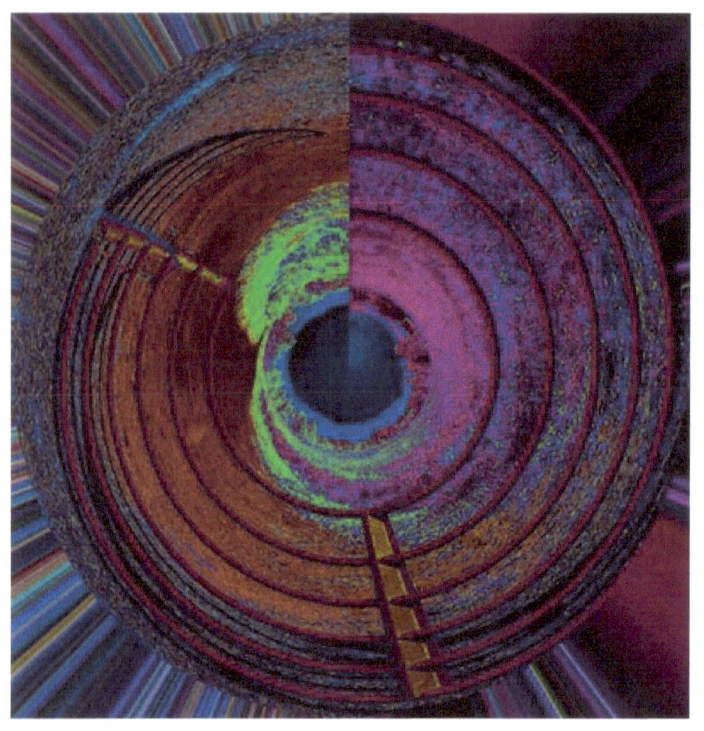

karma

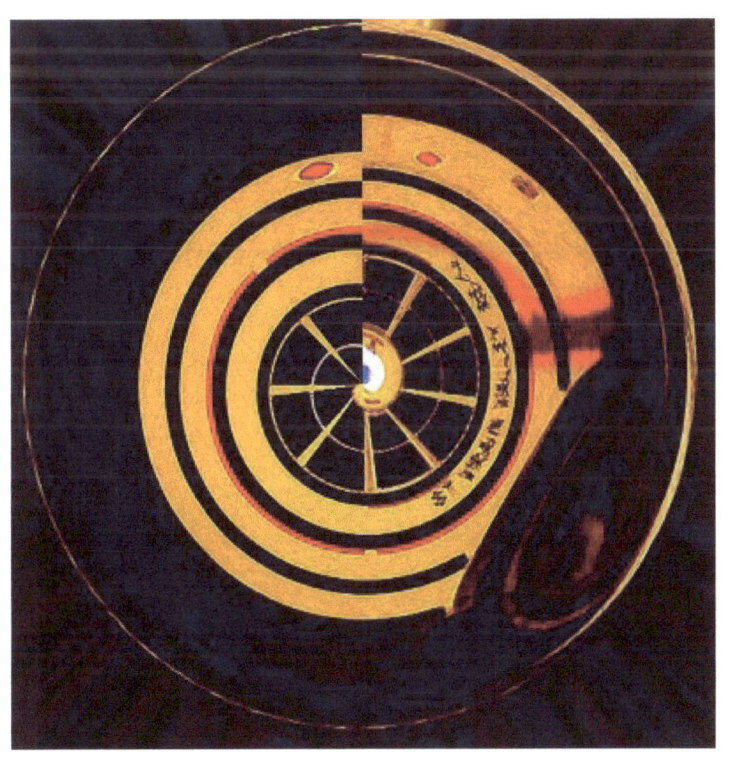

knowledge

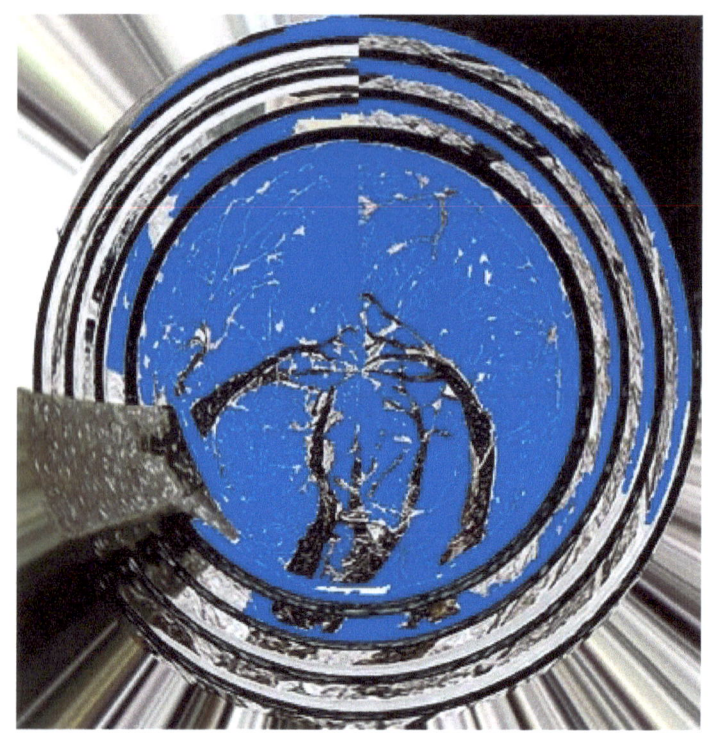

loneliness

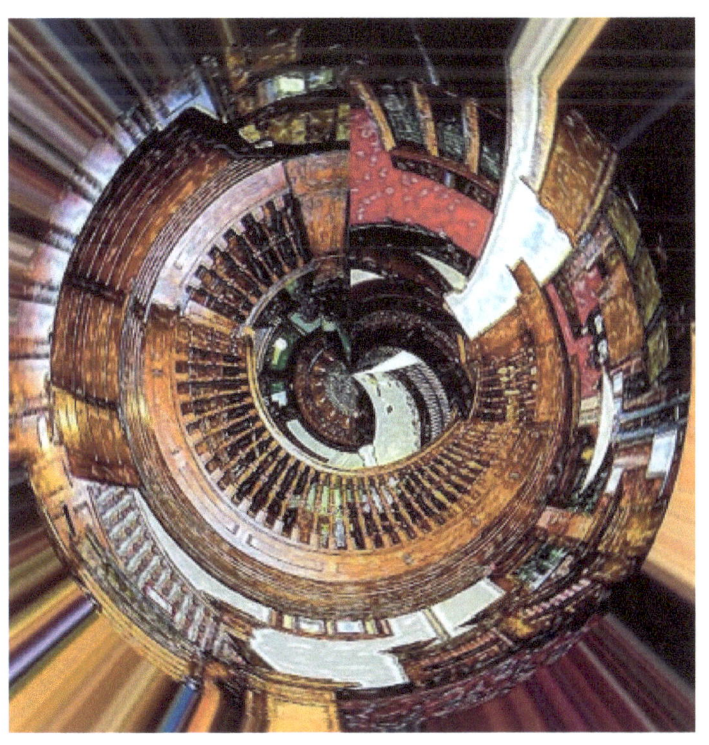

looking up mandala

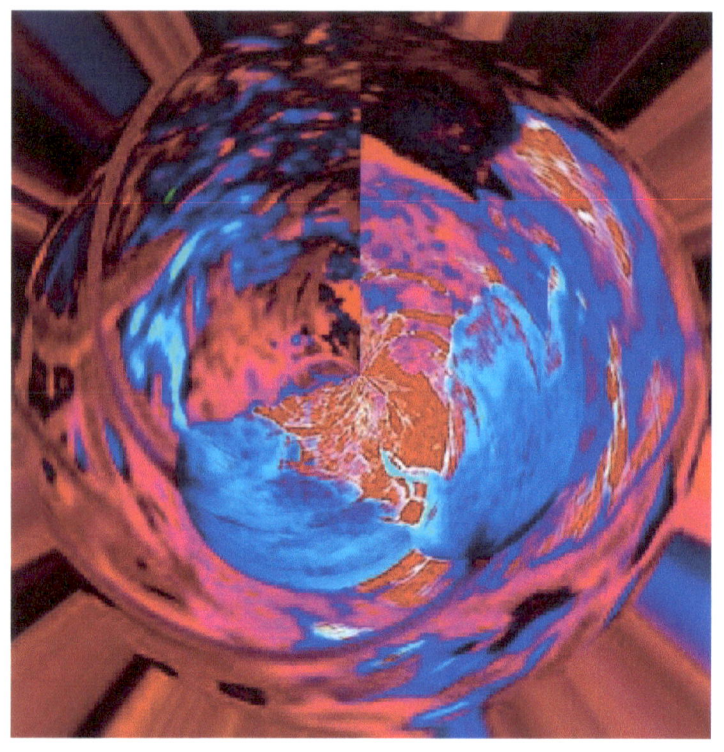

love

madness

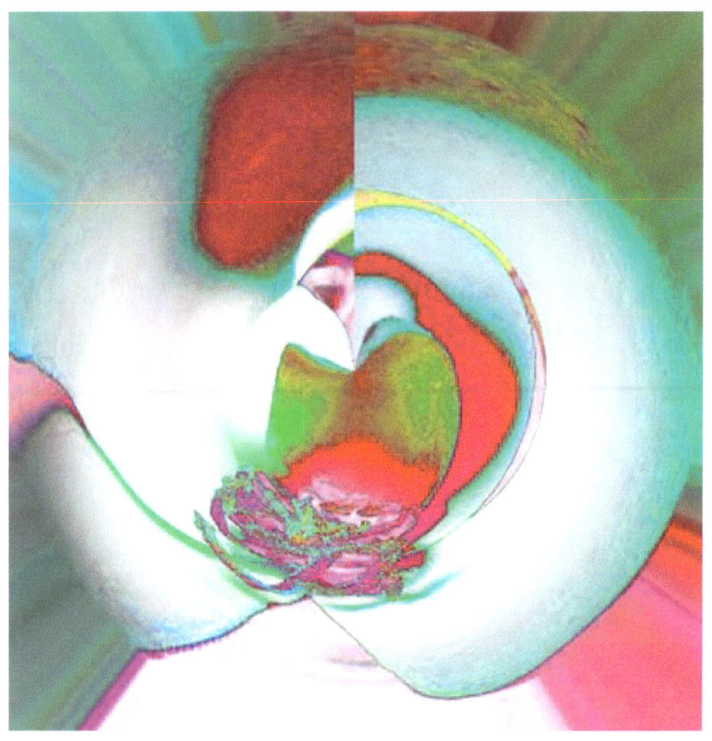

magic

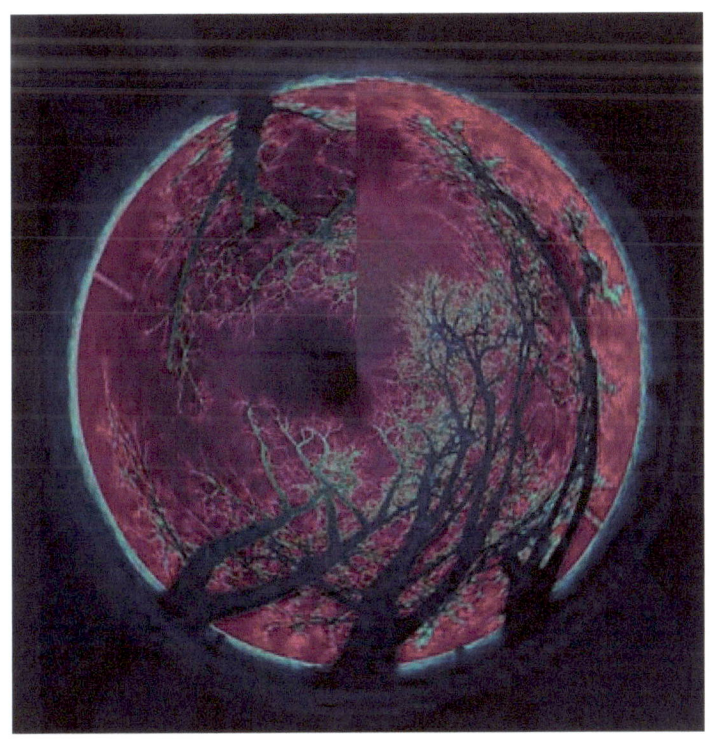

memory

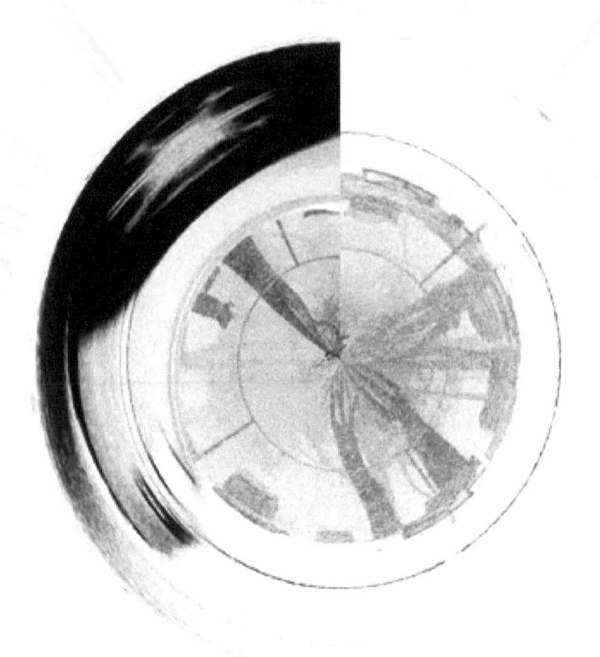

mortality

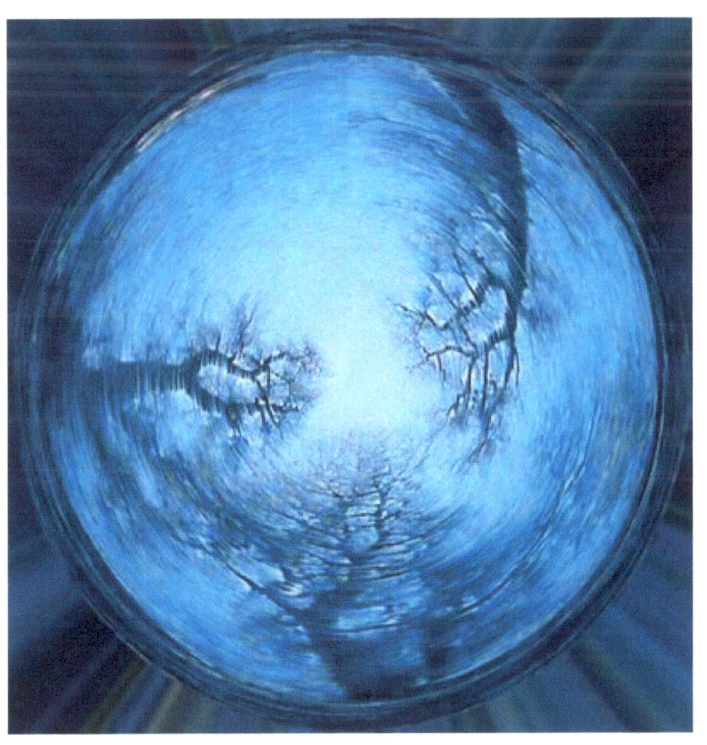

mystery

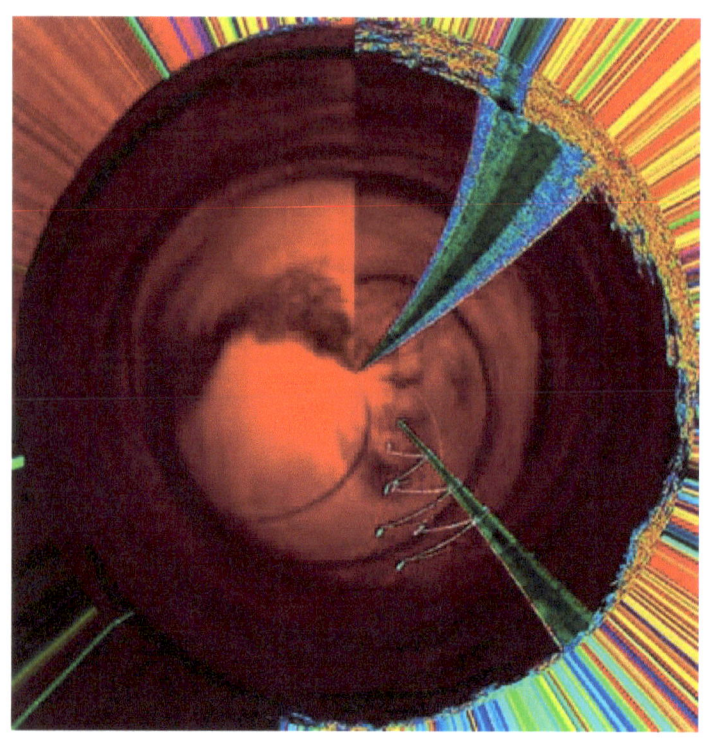

pain

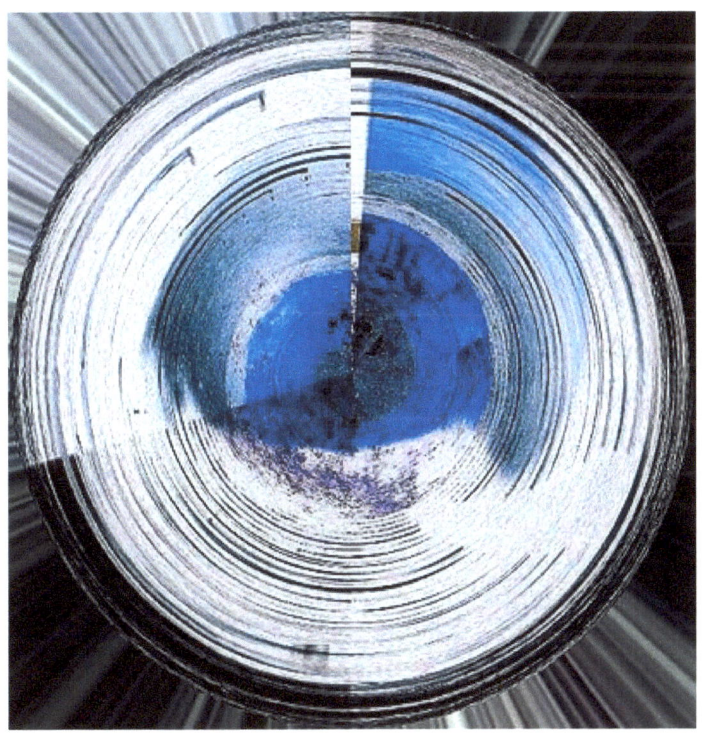

patience

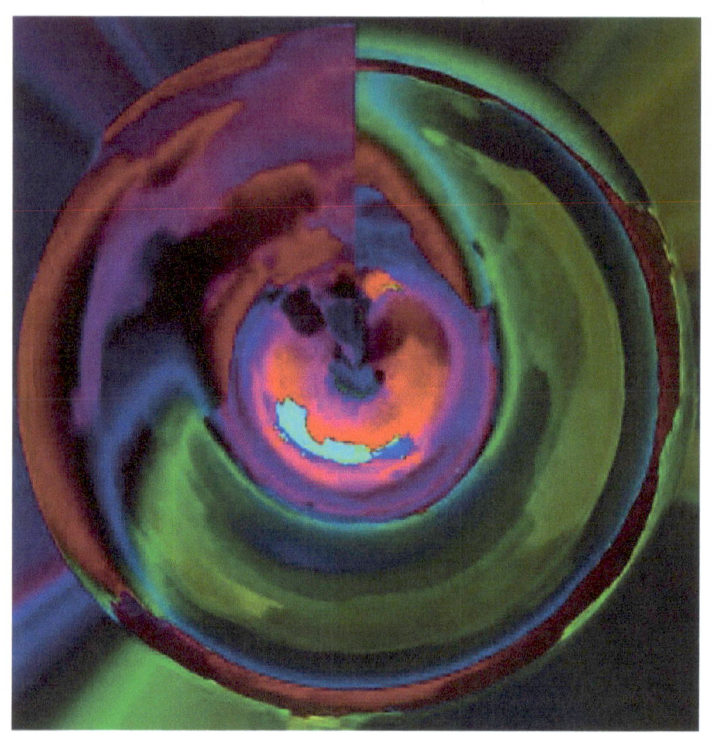

peace

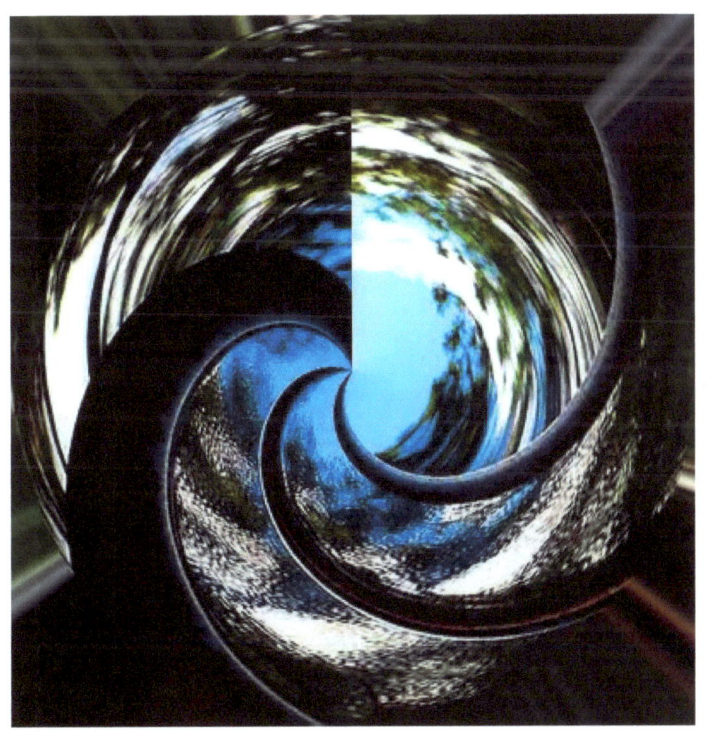

perspective

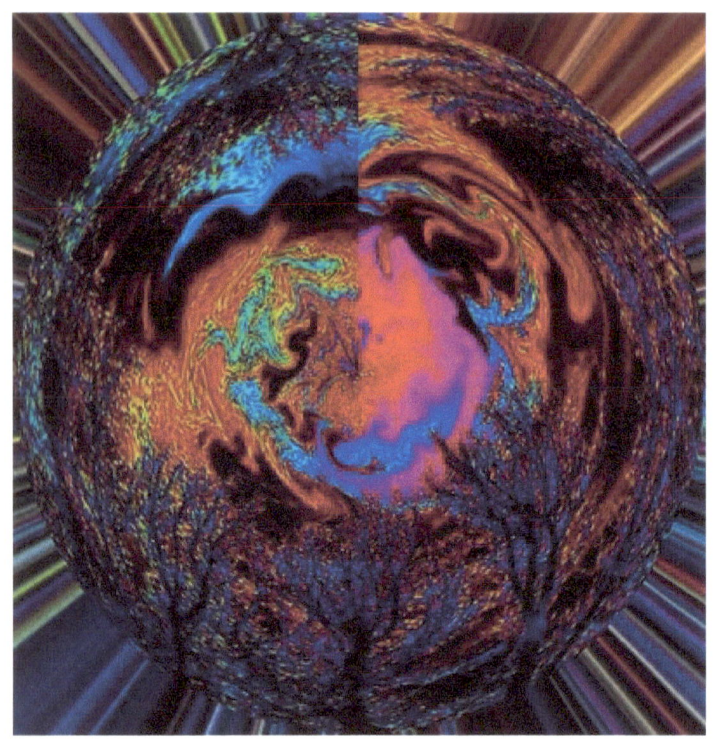

pride

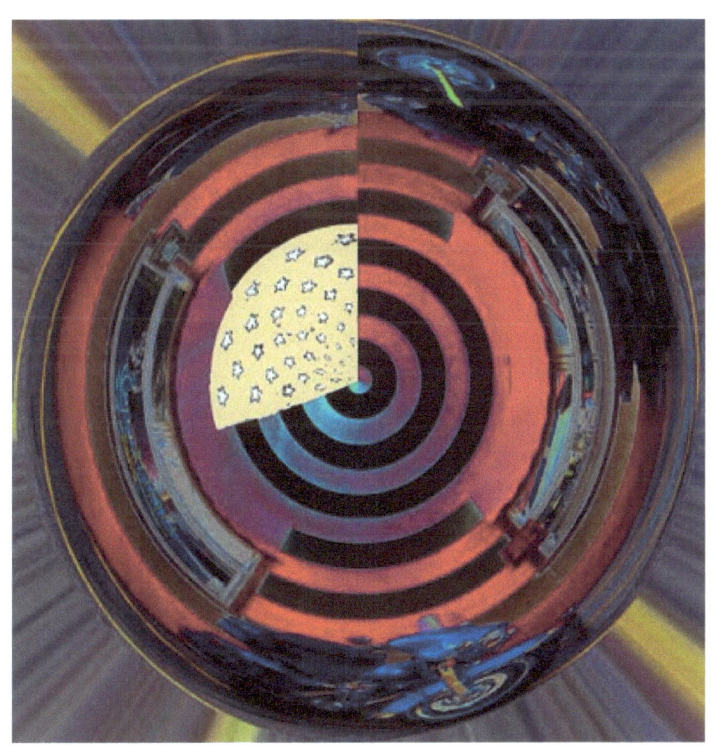

ramble on mandala

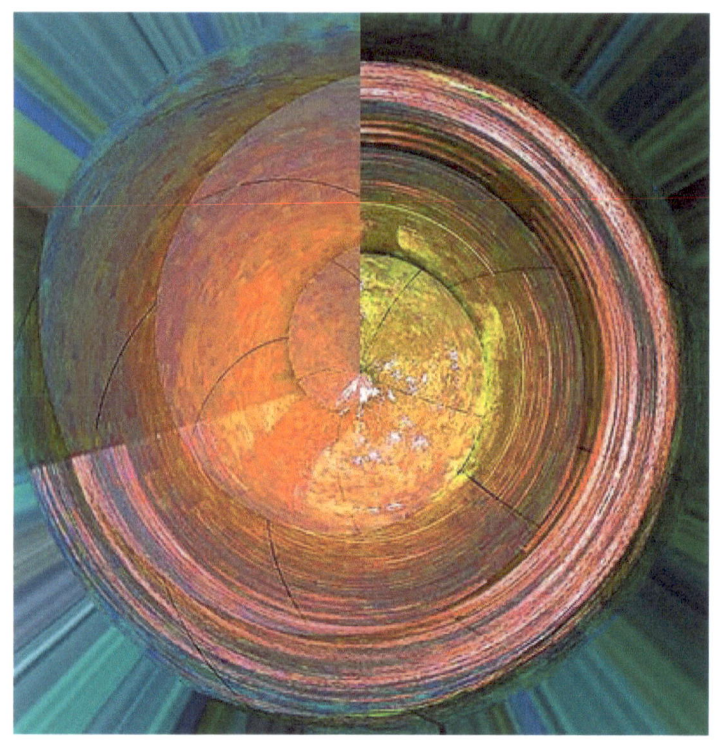

rapture

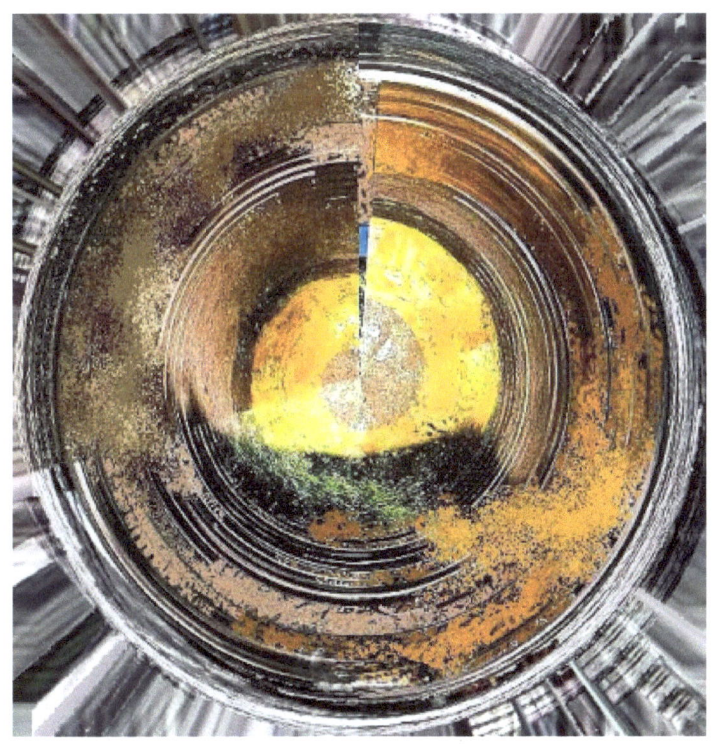

recognition

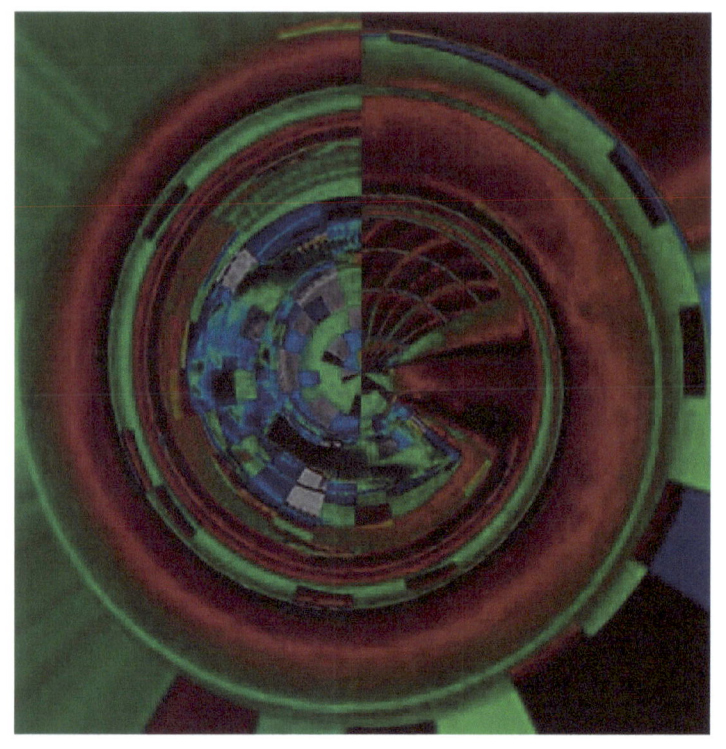

reflection

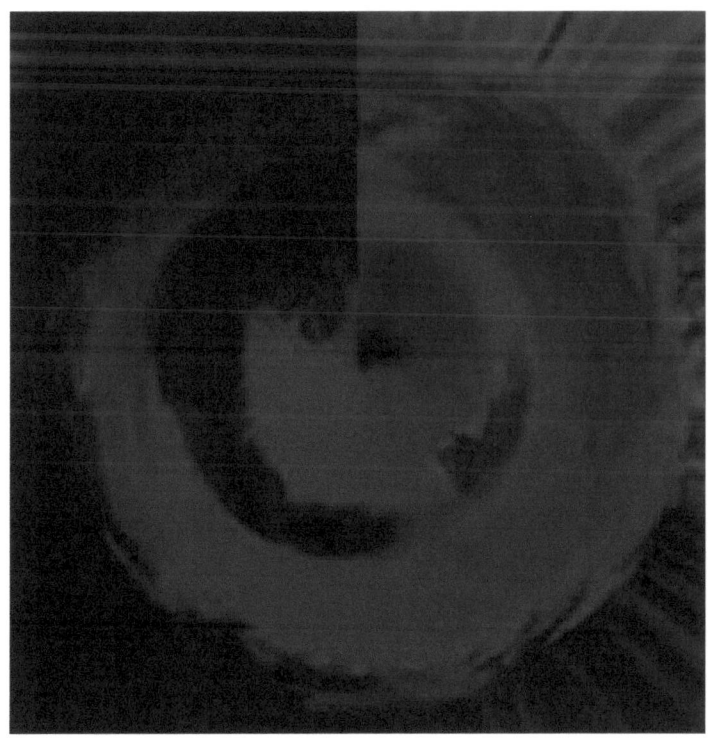

regret

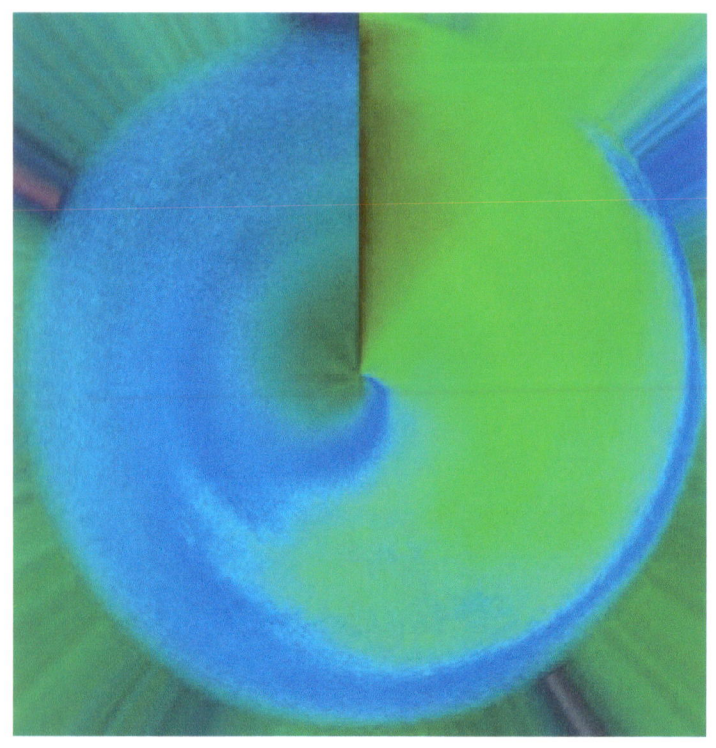

satisfaction

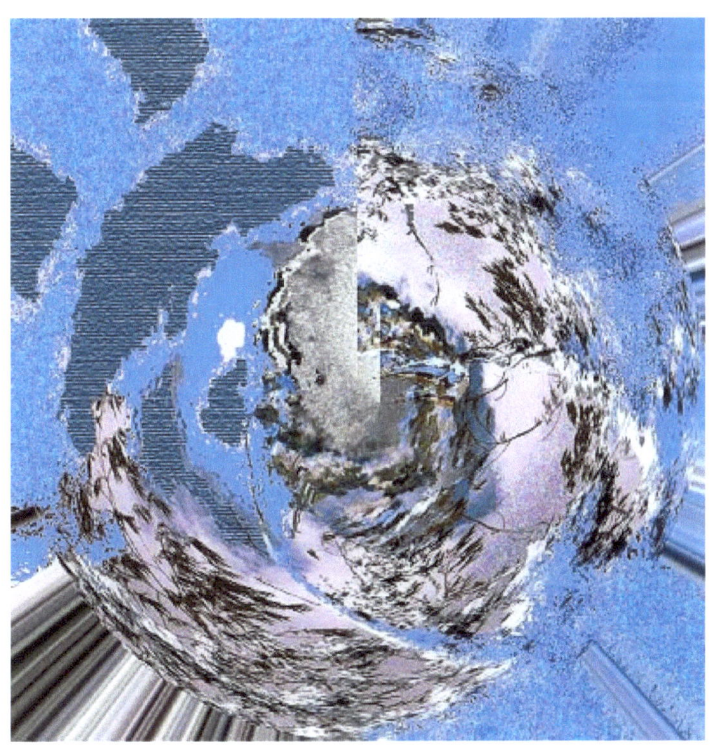

speed

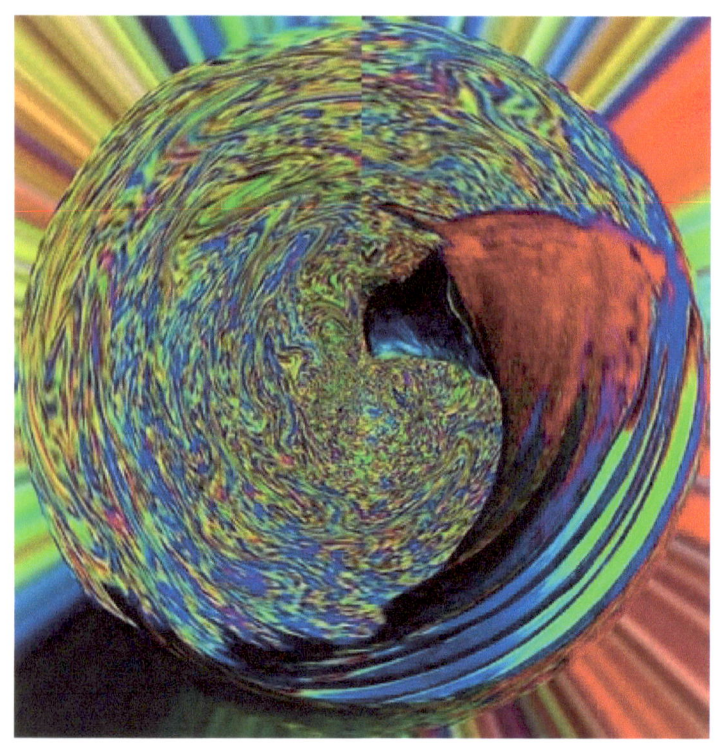

surprise

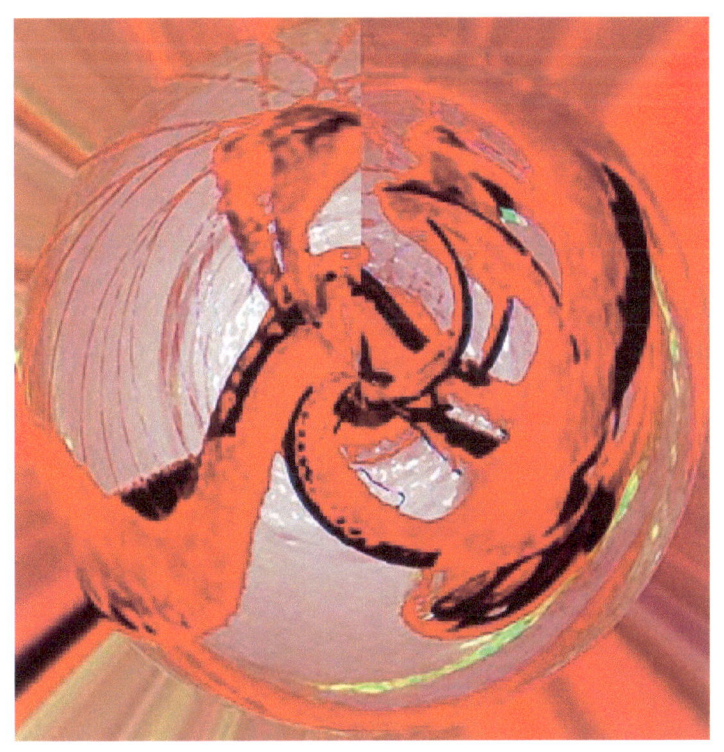

terror

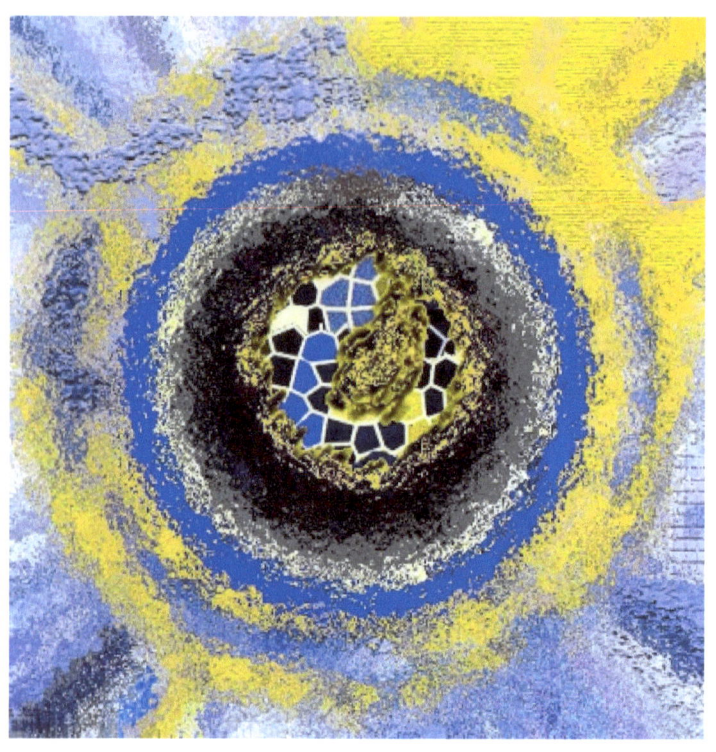

the dance is a poem of which
each movement is a world

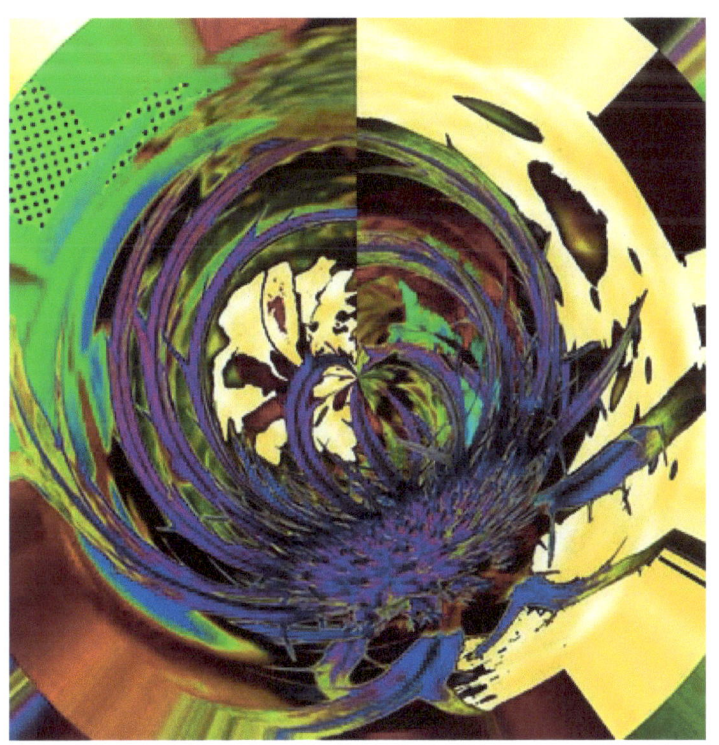

the essential iron and wine
mandala

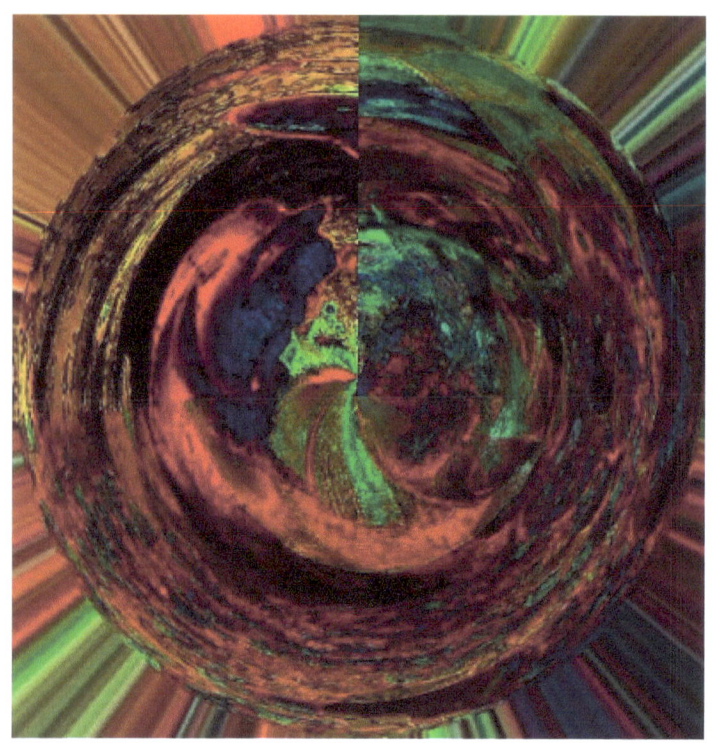

the meaning of life mandala

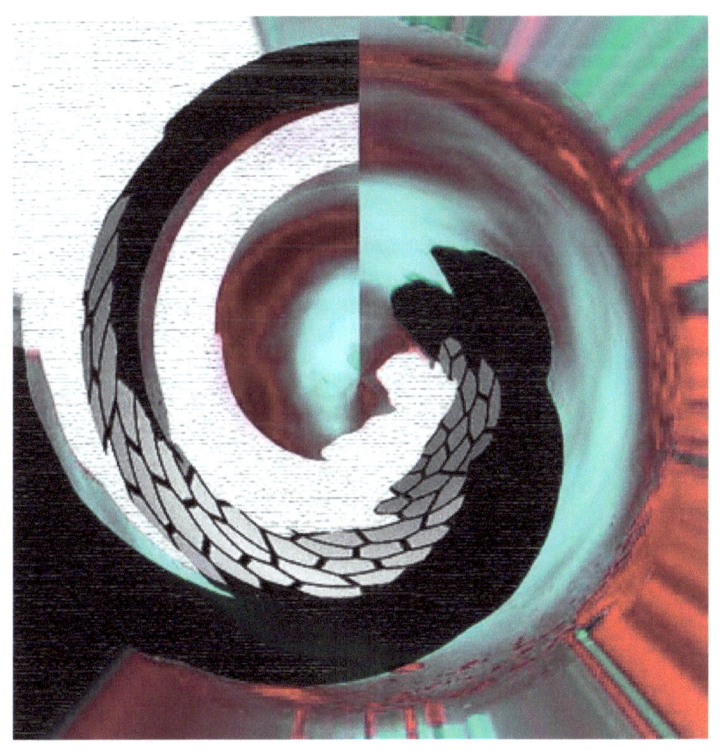

the most important thing in life
is to learn how to give out love
and to let it come in

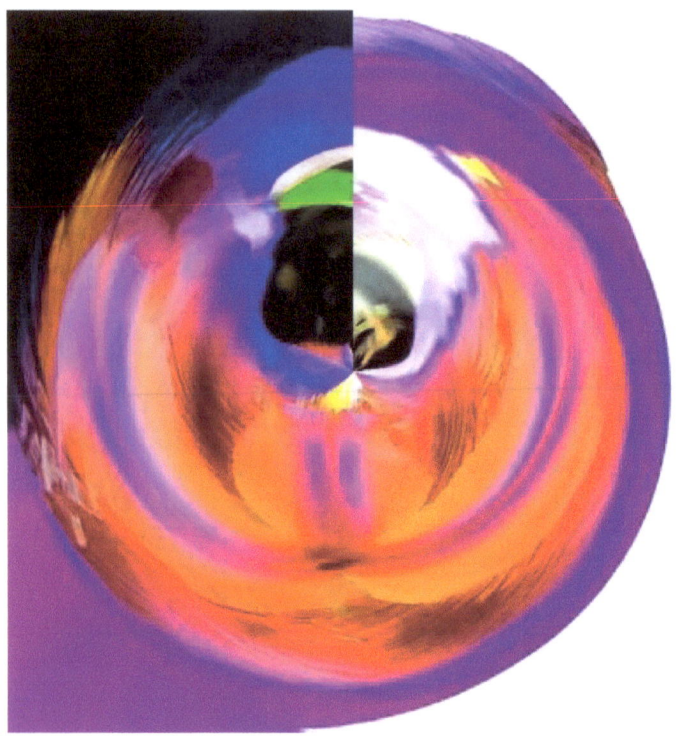

the most important things in
life arent things mandala

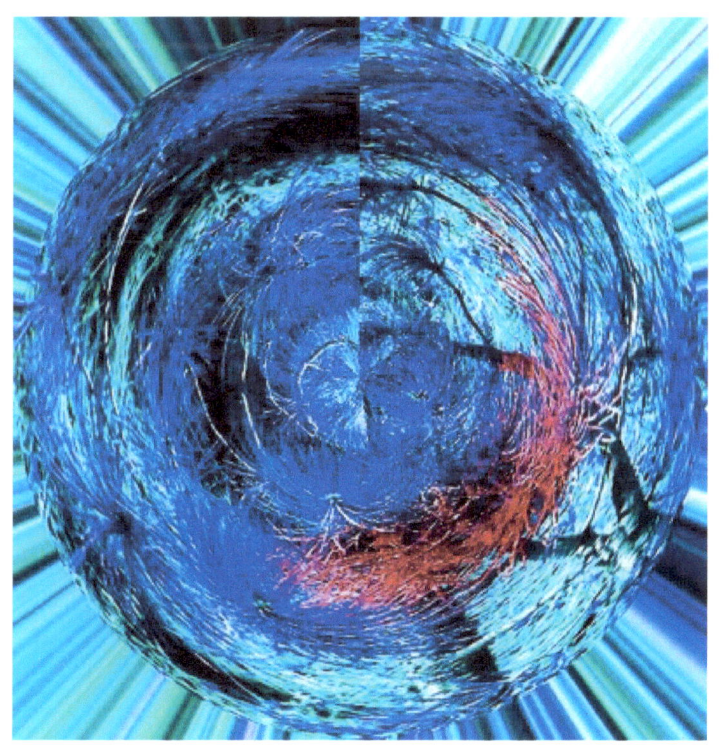

this is the love and friendship mandala

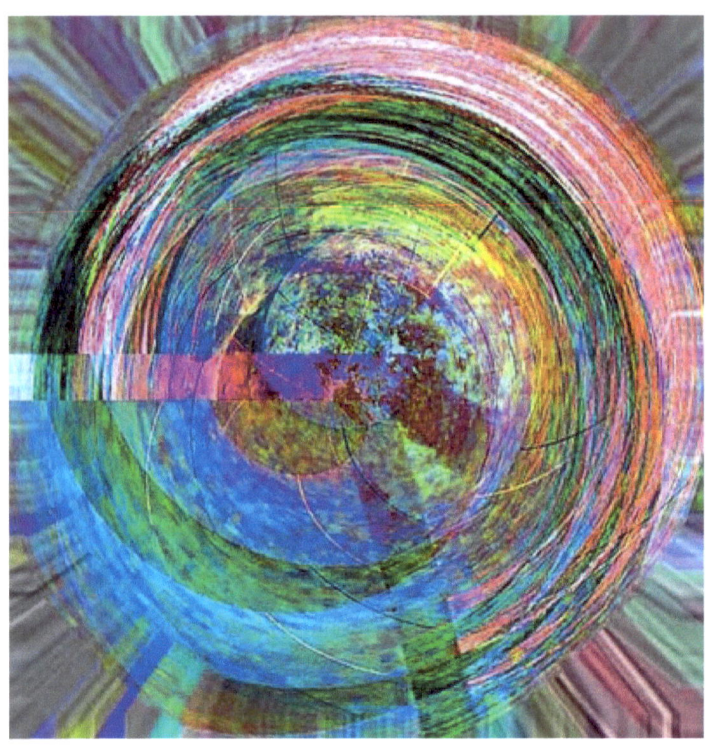

this is the missing you mandala

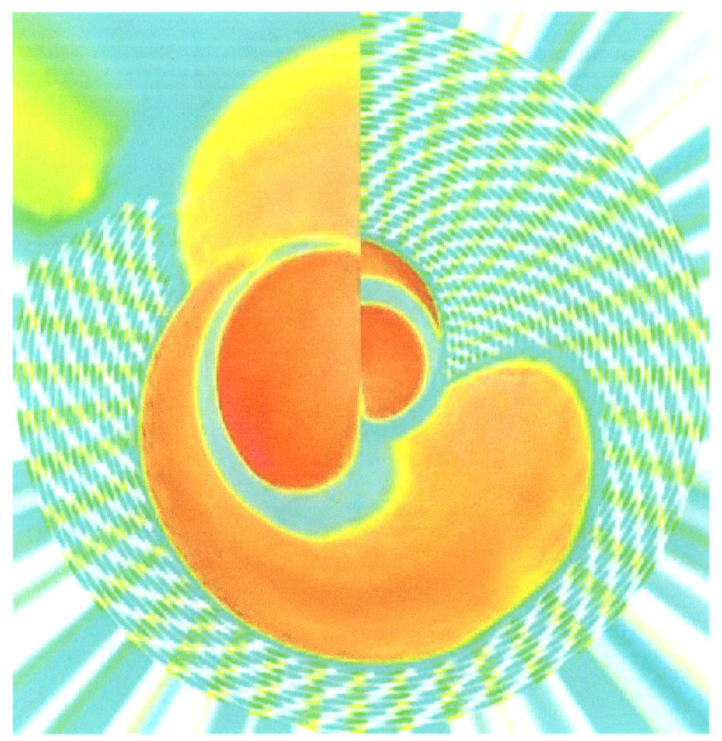

this is the new beginning mandala

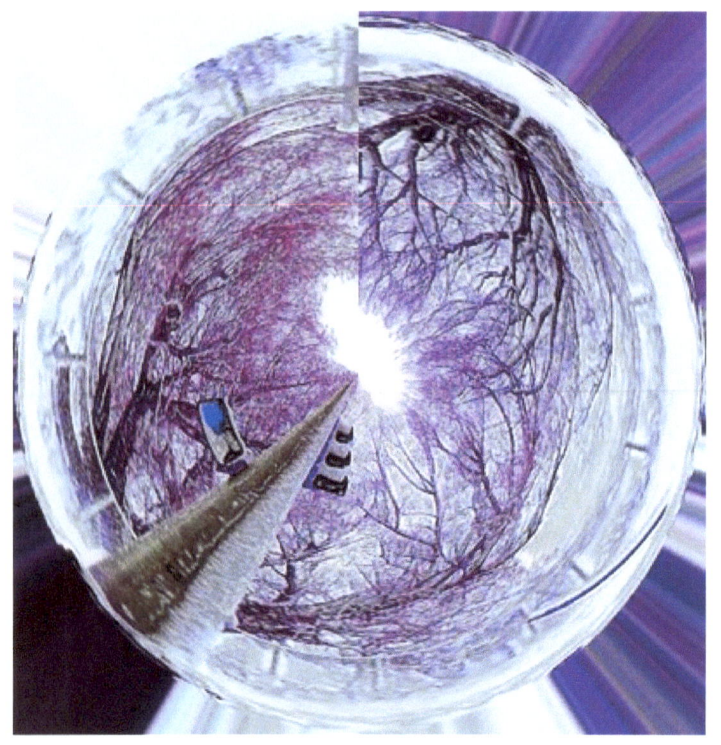

time

www.ingramcontent.com/pod-product-compliance
Lightning Source LLC
Chambersburg PA
CBHW041103180526
45172CB00001B/80